IMAGES
of America

DEPTFORD
TOWNSHIP

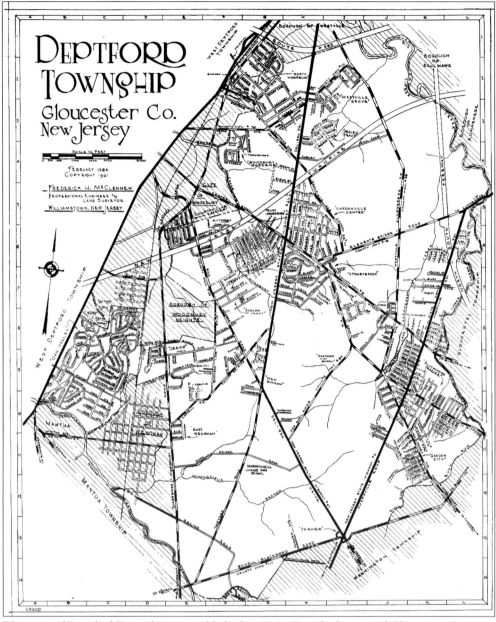

This map of Deptford Township was published in 1964. Deptford is one of Gloucester County's original townships. Today, it is a great place to live, work, and play and has become the commercial and educational hub of Gloucester County.

IMAGES
of America
DEPTFORD
TOWNSHIP

Marie Scholding
with the Deptford Public Library staff

ARCADIA

First printed in 2003.

Published by Arcadia Publishing,
an imprint of Tempus Publishing Inc.
2A Cumberland Street
Charleston, SC 29401

Printed in Great Britain.

Library of Congress Catalog Card Number: 2002115606

For all general information, contact Arcadia Publishing:
Telephone 843-853-2070
Fax 843-853-0044
E-mail sales@arcadiapublishing.com

For customer service and orders:
Toll-free 1-888-313-2665

Visit us on the Internet at www.arcadiapublishing.com.

On the cover: This photograph was taken *c.* 1910 at the Monongahela one-room schoolhouse, located on Tanyard Road across from the present-day entrance to Gloucester County Community College. The photograph is courtesy of Robert Scott, whose father and two uncles attended the school.

CONTENTS

ACKNOWLEDGMENTS

During my 31-year tenure as the reference librarian at the Deptford Public Library, I have gained many friends in the Deptford community. These friends provided me with the knowledge about Deptford to make this book project a reality. I wish to acknowledge the group effort of the entire library staff in bringing this project to fruition. Library director Arn Ellsworth Winter, children's librarian Susann Kaback, Mary Lamana, Catherine "Bunny" Jacobsen, Jean McGowan, Ruth Stankiewicz, Jane Tessmer, Patricia "Trish" Whyte, Linda Ruple, Carol Creghan, Linda St. Pierre, Mary Cutrufello, Audrey Vollmer, and Karen Countryman all played an important role in helping write text, in collecting photographs, and in preparing pages. In addition, this endeavor was greatly supported by the library board president, Judith Tanger, and the other board members. Mayor William Bain and the town council support our efforts at the library every day, and to them I am greatly indebted.

The entire staff of the Deptford Public Library wishes to thank the following for their help and support in compiling this pictorial history of Deptford Township: John Selby, Karl Ludvigsen, Al Cunard III, Gladys Pierson, John Tull, Josephine Andaloro, Jack Heritage, Steve Moylan, Michael Gallagher, Ellen Massa, Robert and Judith Scott, Stanley Peterson, Joan Tracy, Alfred Coy, Michelle Mostovylan, Herbert I. Clement Jr., Judy Clement Hensel, Marie Hendrix, Marge Leo, Jane McDemott, Michael Stronski, Narcissa Weatherby, Mary Ellen Colgan, Lillian Creen, Howard Johnson, the Courier Post, and the Gloucester County Historical Society.

INTRODUCTION

Deptford is one of the five original townships created when Gloucester County was incorporated on June 1, 1695. This area of southern New Jersey was first settled by the Dutch in 1623 under the leadership of Cornelius Jacobse Mey. Within a few years, the area was claimed by the Swedes and the Finns before eventually coming under British control. At the time of Gloucester County's formation, Deptford Township was known as a river township encompassing a large geographical area of more than 100 square miles that included the towns known today as Woodbury, West Deptford, National Park, Wenonah, Woodbury Heights, Washington Township, and Monroe Township. Deptford Township was originally called Bethlehem. It was then called Deerford and finally became Deptford after the old English seaport town on the River Thames downstream from London.

Early settlement patterns in the township were scattered throughout the area. Deptford remained rural and heavily wooded long after the first Europeans began building their homes and farms. Some of the first areas that saw development of residential and commercial properties were in the area of Almonesson Lake and Clements Bridge, followed by growth in Woodbury and sections along the Woodbury-to-Glassboro corridor.

In 1830, the original township of Deptford had a population of 3,599 and an area of 57,600 acres. During the 1800s, Gloucester County underwent enormous growth of population, resulting in the creation of new political divisions. Deptford lost its large geographical area but gradually gained a much larger population. Commercialization slowly began to change the rural atmosphere in Deptford. In 1832, the area boasted a ferry, a distillery, a glass factory, 1,389 neat cattle, and 672 horses and mules above the age of three years. Today, Deptford Township, with an area of 17.5 square miles, is a vibrant and growing community, as is reflected by its population increasing from 4,738 in the 1940 census to 26,763 in 2002. Population growth over the last 75 years has increased the size of the township many times over. Many educational facilities make Deptford their home. Along with Deptford Township High School, the County Special Services School and the Gloucester County Institute of Technology are located inside the township. In addition, Gloucester County Community College began operating in Deptford in 1968.

Development and growth in Deptford followed a clustering pattern as small communities began to grow in a few areas of the township. One of the first clusters began around the area of Almonesson Lake. Almonesson, a Native American name meaning "young fox place," was founded in 1789 by Daniel Lamb. Almonesson Lake produced tons of ice each winter and

became the major ice producer in the region. In 1830, Charles Lamb built a cotton mill and also built the first store in the town. The first school in Almonesson was built in 1839. Almonesson Lake Park, begun in 1874, attracted summer visitors from as far away as Philadelphia. In 1894, a trolley brought visitors from Woodbury to Almonesson and was still used in 1927. The lake became a favorite weekend and summer retreat for Philadelphians, with many summer homes and cottages built around the lake and spreading into the area now known as Blackwood Terrace.

Almonesson Lake Park later boasted a bowling alley, which eventually burned down, and a roller-skating rink. Swimming and canoeing on the lake were popular summer activities for over 100 years before ending in the mid-20th century, when the water became a little too polluted to support swimming. During the 1970s, the township built a public swimming pool in an area off Delsea Drive to accommodate local swimmers. Eventually Fasola Park, with its pool, playgrounds, and ball fields, became the township's center of outdoor recreation.

For many years, the township's premier thoroughfare was Delsea Drive (earlier known as Westville-Glassboro Road). This grand route from the Delaware River to the Atlantic Ocean was laid in the mid-1800s. By the 1870s, nearly every major road in Deptford now in existence was already in use and can be easily spotted on 19th-century maps of Gloucester County. Development along Delsea Drive is highlighted by the settlement in 1847 of the Jericho and New Sharon areas. Jericho was settled by John Dorsey and further developed by Benjamin Briggs. In 1877, Jericho erected its first school and first church, the Jericho Mission Church.

About 100 years ago, some of the patterns of residential and commercial development seen today began to become apparent. Suburban growth along Delsea Highway and along the trolley and railroad lines began to shape the township into its present pattern of communities. The settlement clustering pattern of earlier days continued throughout Deptford's history. Today these original settlement areas of the township have become small, unique communities. In addition, housing projects have created many new residential subdivisions.

Significant contributions to New Jersey and U.S. history occurred in Deptford. In 1793, Frenchman Jean-Pierre Blanchard made the first successful balloon flight in America. Blanchard launched his balloon in Philadelphia, carrying a well-wishing letter penned by George Washington. A short time later and just 14 miles east of Philadelphia, Blanchard completed the first manned flight in America by touching down in Deptford. In his honor, an area of the community is now known as Blanchard's Landing. Revolutionary War hero Jonas Cattell was born in Deptford. It was army scout Cattell who warned Col. Christopher Greene of the Revolutionary forces that Hessian soldiers were approaching nearby Fort Mercer. Greene quickly sent reinforcements, which enabled the Colonial soldiers to defeat the British at the Battle of Red Bank.

Today's vibrant community of Deptford began to boom at the end of World War II. North Woodbury, Westville Grove, Jericho, New Sharon, Blackwood Terrace, and Almonesson were established as residential areas shortly after the end of the war. Cooper Village was developed in the 1950s on land that had once been the Lavender Hill Plantation owned by Jonas Cattel. Beginning as a heavily wooded and rural community, Deptford was awakened in 1974, when the Deptford Mall was opened and businesses began to fill the area around the mall. Deptford is truly a 20th-century phenomenon, going from mainly rural to residential and commercial, with even more planned growth projected in the near future. Deptford is a well-maintained community with beautiful homes, growing businesses, and recreational opportunities for its citizens. It offers residents good roads, excellent educational facilities, many employment opportunities, and first-class shopping while retaining its original rural flavor where friendliness and family always come first.

One
PEOPLE

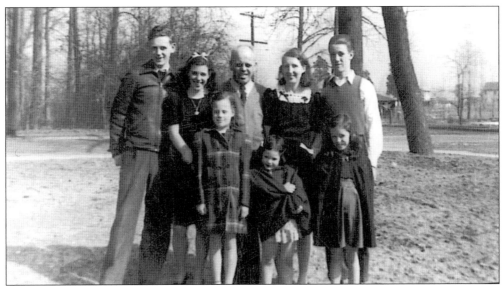

This 1943 photograph shows the Lewis family of Lake Tract beside the road that is now the New Jersey Turnpike. From left to right are the following family members: (front row) Gladys, Doris, and Edith Lewis; (back row) Harry, Mary, Howell, Gladys, and Norm Lewis. (Courtesy of Gladys Pierson.)

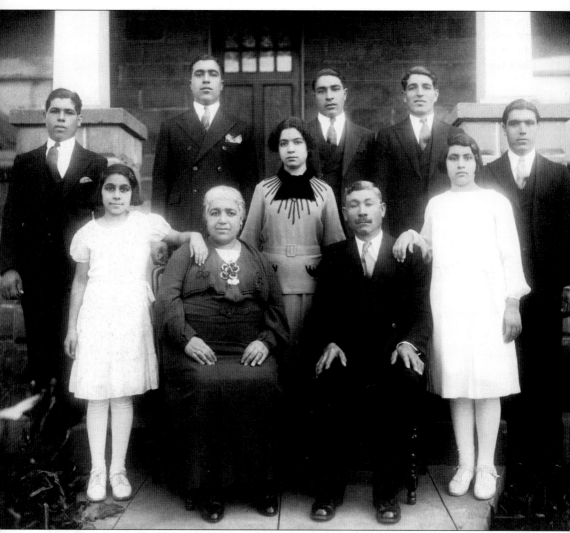

For many years, the Andaloro family of Westville Grove operated a large produce farm. Pictured in this portrait are, from left to right, the following: (front row) daughter Josephine, mother Josephine, Agnes, John Sr., and Mary Andaloro; (back row) John Jr., Sam, Frank, Joseph, and Anthony Andaloro. (Courtesy of Josephine Andaloro.)

This truck on the Andaloro farm carries corn stalks to be used as windbreakers to help keep their greenhouses warm. (Courtesy of Josephine Andaloro.)

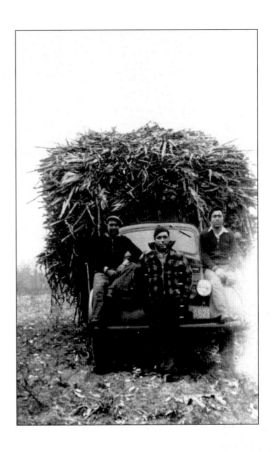

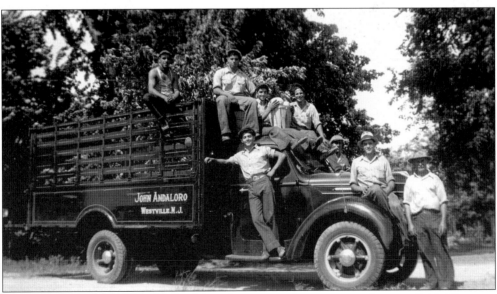

Farm workers on a truck on the Andaloro farm are ready to move to the next field. (Courtesy of Josephine Andaloro.)

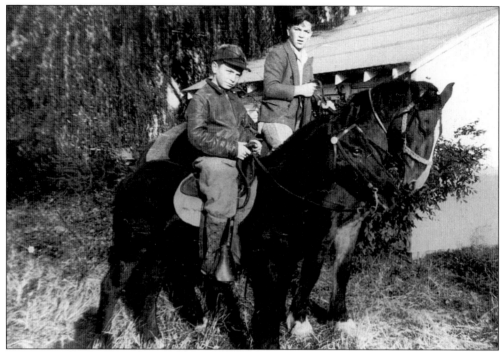

Karl Baker (left) and Raymond Whyte ride their horses on Second Avenue in Westville Grove in 1942. (Courtesy of Raymond Whyte.)

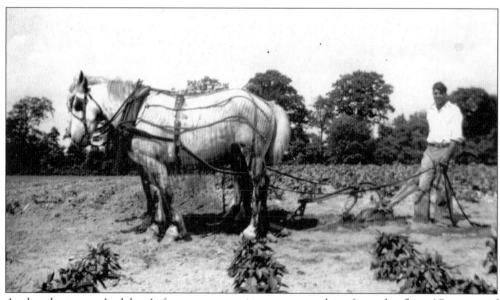

A plow horse on Andaloro's farm wears netting to protect him from the flies. (Courtesy of Josephine Andaloro.)

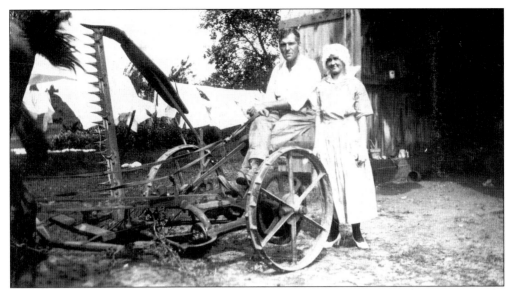

This photograph was taken *c.* 1921 on a farm where the Freeway Diner now stands on Route 41. (Courtesy of John Selby.)

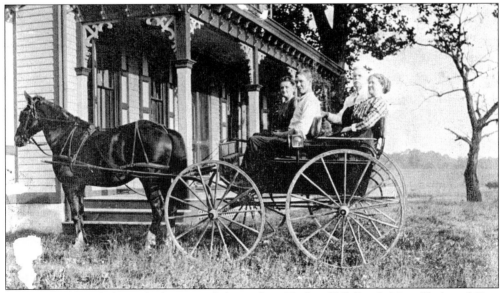

Pictured is the Clark family homestead, located on Turkey Hill Road. Mrs. Clark and Pete Colgan ride in the front seat of the carriage. The man and woman in the back seat are unidentified. The picture was taken between 1915 and 1919. (Courtesy of Mary Ellen Colgan.)

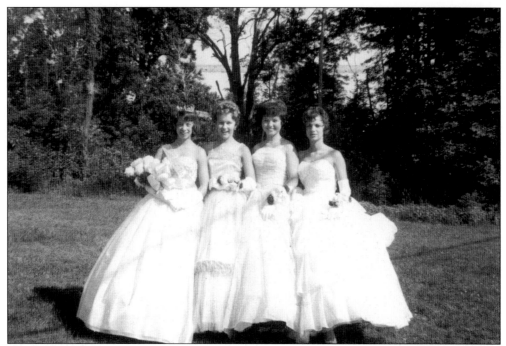

This photograph appeared in the *Oak Valley Observer* in August 1962. On the left is the new Miss Oak Valley, Nancy Sperry. Her court includes, from left to right, Virginia Cope, Kathy O'Hare, and Kathy Bilotti. (Courtesy of John Albert.)

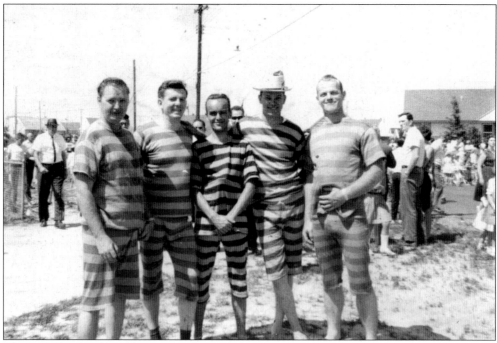

This Fourth of July celebration and parade held in Oak Valley in 1962 features the Lake Committee Group sporting old-fashioned swimming gear. From left to right are T. Johnson, J. Markey, V. Richardson, and Bill Richert. (Courtesy of John Albert.)

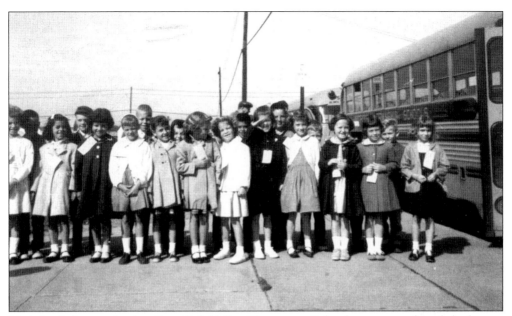

Mrs. Ross's first-grade class from Oak Valley Elementary School prepares to board the bus on their way to the Philadelphia Zoo. (Courtesy of John Albert.)

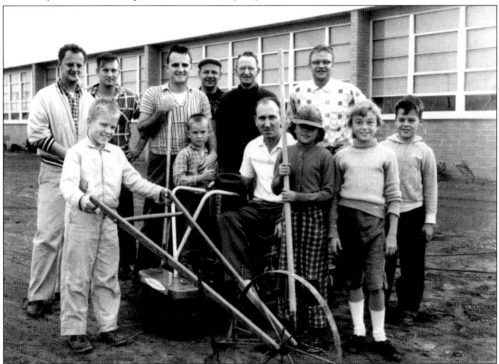

The men surrounding Hugh Baxter on the power mower tractor at Oak Valley Elementary School are, from left to right, Ted ?, Herbert Manogue, Judge John Weatherby, and Wesley Weber. The children are, from left to right, Walter Weber, Richard Kell Jr., Linda and Patty Richardson, and Nicky Manogue. They were all helping to landscape the grounds at the new school. (Courtesy of John Albert.)

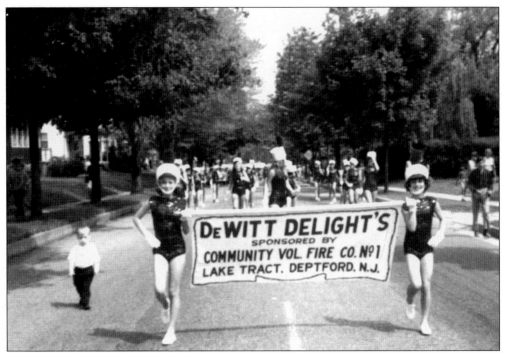

Members of DeWitt's Delights, a local baton group under the direction of Edith DeWitt of Lake Tract, march in a parade on May 30, 1968. (Courtesy of Edith DeWitt.)

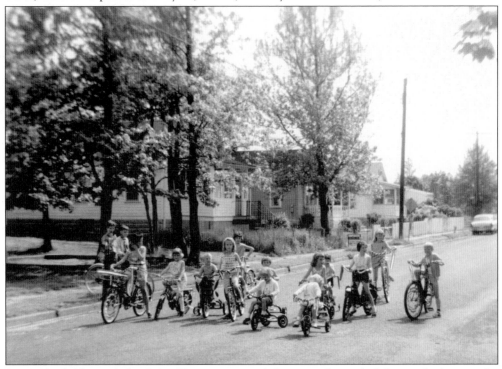

In 1966, children of the Lake Tract section of the township ride bikes and play on the playground where the parking lot of the Elks Club is now. (Courtesy of Nellie Underwood.)

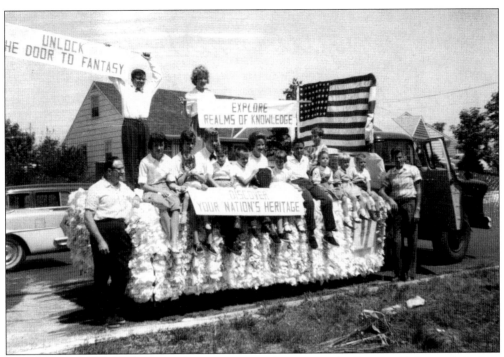

The float of the Deptford Library Association won first prize in the Fourth of July parade in Oak Valley in 1963. (Courtesy of John Albert.)

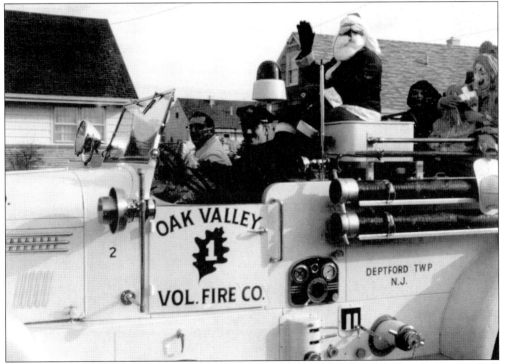

Santa Claus toured Oak Valley in style in the fire company truck in 1962 with firemen Bob Hofert and Bill Smith acting as his helpers. (Courtesy of John Albert.)

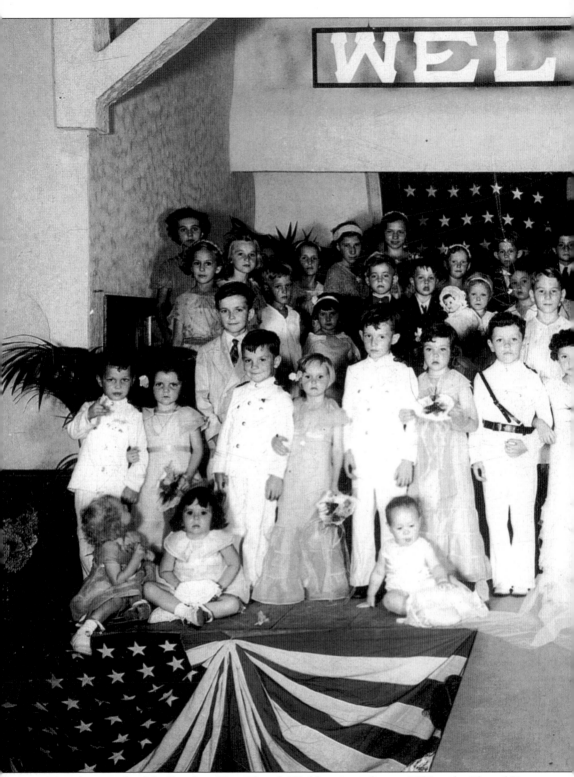

This photograph of the Rainbow Tom Thumb Wedding was taken in 1937 at the Blessed Hope

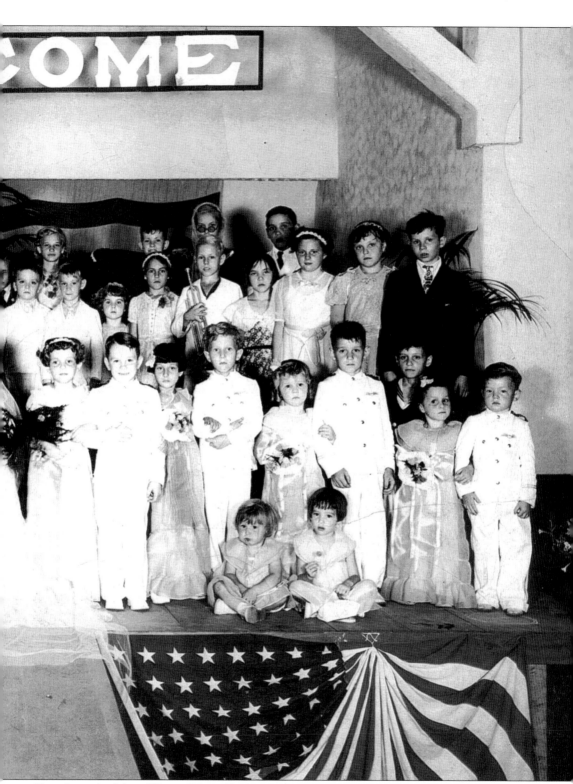

Church on Andaloro Way in Westville Grove. (Courtesy of Raymond Whyte.)

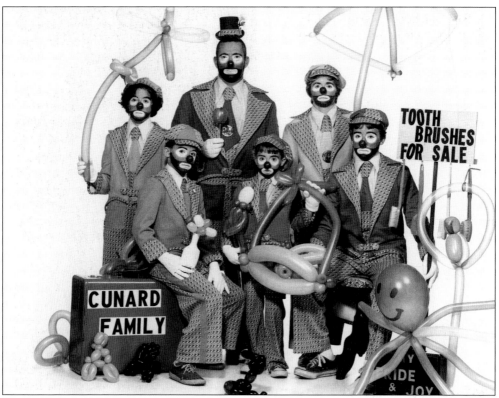

For over 40 years, the Cunard family has been performing as clowns for parades and organizations. From left to right are the following: (front row) Andy Cunard, Al Cunard IV, and Mark Cunard; (back row) Susan Cunard, Al Cunard III, and Linda Cunard. (Courtesy of Al Cunard III.)

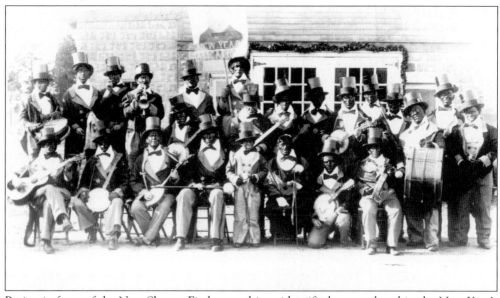

Posing in front of the New Sharon Firehouse, this unidentified group played in the New Year's parade in Philadelphia. The date of the photograph is unknown. (Courtesy of John Selby.)

Uncle Sam marches in a Fourth of July parade in Westville Grove. (Courtesy of Josephine Andaloro.)

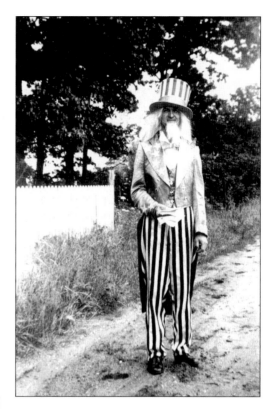

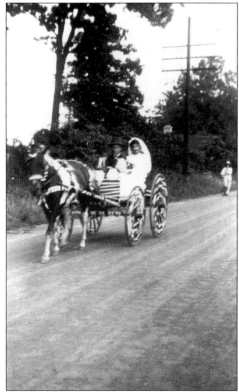

This photograph shows another participant in the Fourth of July parade of 1956 in Westville Grove. (Courtesy of Josephine Andaloro.)

Ellen Leadbeater stands in front of St. John Vianny in Blackwood Terrace. The date of the photograph is unknown. (Courtesy of Ellen Massa.)

In 1943, the Victory Corps was formed to help out in the war effort. Women and children were sent to work on the farms to replace the men who went into the military. This photograph was taken on the Andaloro farm. (Courtesy of Josephine Andaloro.)

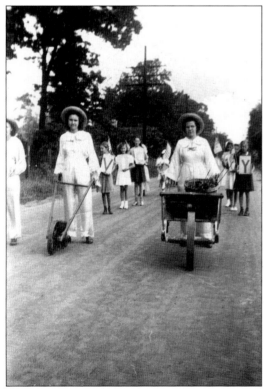

The Victory Corps of women and children marched in this Fourth of July parade in Westville Grove. (Courtesy of Josephine Andaloro.)

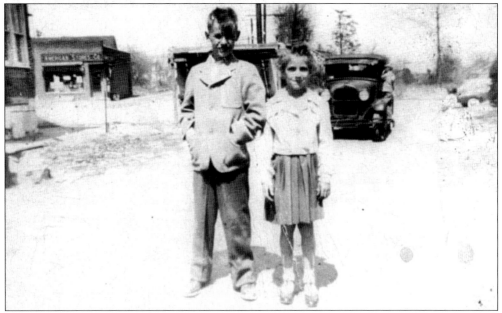

Ellen and Charles Leadbeater stand in front of the icehouse on Good Intent Road in Blackwood Terrace. To the rear is the old Acme store. This photograph was taken in 1946. (Courtesy of Ellen Massa.)

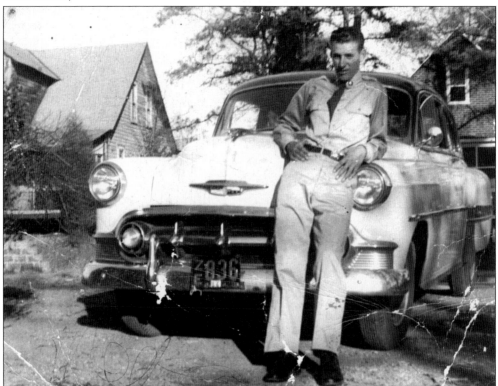

Charles Leadbeater stands in front of his car on Fifth Avenue in Blackwood Terrace. (Courtesy of Ellen Massa.)

Ellen Leadbeater rides her Tennessee walker horse on Fifth Avenue in Blackwood Terrace. (Courtesy of Ellen Massa.)

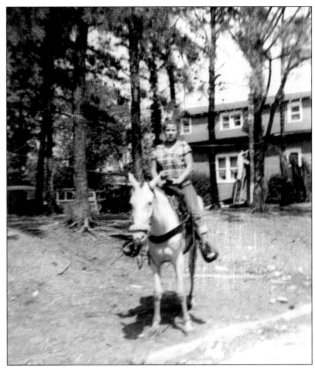

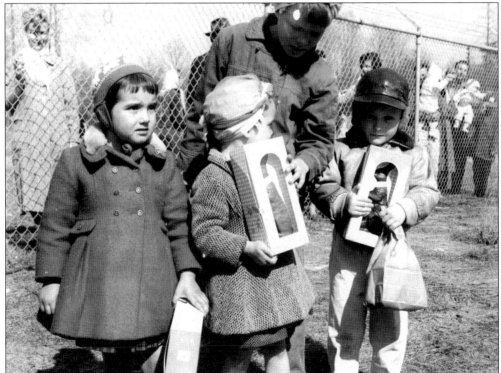

Susan Bailey (left), Betty Ann Leyh, and Billy Shaffer participate in an Easter egg hunt in Oak Valley in 1961. (Courtesy of John Albert.)

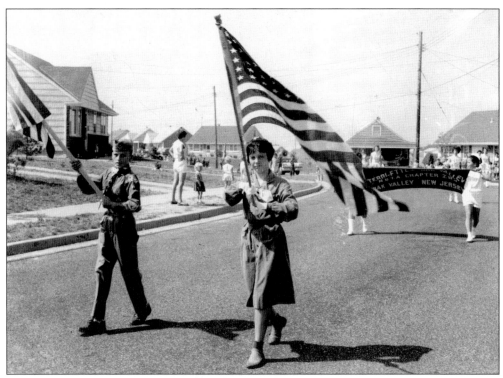

Oak Valley residents show their patriotism by participating in a parade honoring our great nation. (Courtesy of John Albert.)

Pictured is another of Oak Valley's patriotic parades. (Courtesy of John Albert.)

Two
BUSINESSES

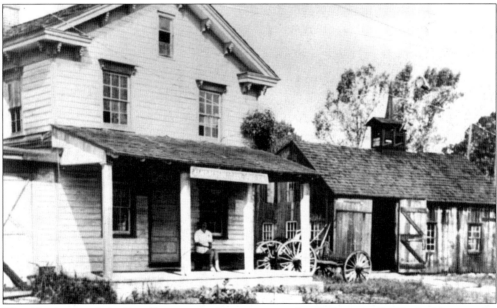

The Almonesson Lake Fire Company is shown in an undated photograph. The building on the right was the local blacksmith shop, which also served as a wheelwright shop, where wagon wheels were built and repaired. The blacksmith shop later became the Bung Drivers Club (members hit wooden spigots into beer barrels) and was eventually bought by the adjoining firehouse. A fire truck was kept in the garage at the left. The woman in the photograph is Ethel Ludvigsen, the wife of Karl Ludvigsen. (Courtesy of John Selby.)

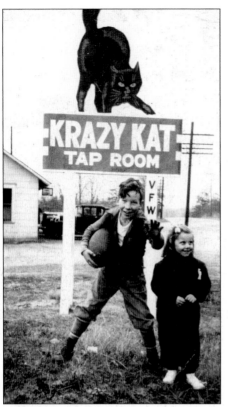

The Krazy Kat has been a fixture in the community for many years. The Krazy Kat Lounge is still located on the corner of Route 41 and Cooper Street in the Almonesson section of Deptford. In 1925, William McGroarty purchased the ground from Mart Caulfield to begin a business. (Courtesy of John Selby.)

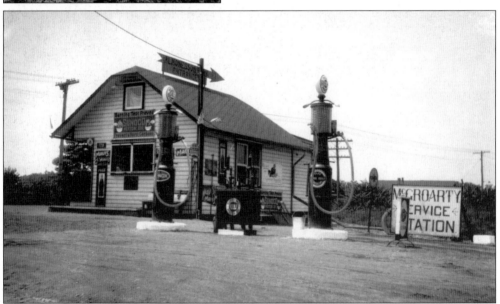

In 1927, the Krazy Kat operated as a gas station, selling Sunoco gas, soda, ice cream, and hot dogs. This 1929 photograph shows the original building. In 1931, a larger building was constructed next door. In 1933, when beer became legal, the name changed to the Krazy Kat Inn. In 1948, the property was sold to a Mr. Levering and then to a Mr. Orlando, who built an addition on the rear of the building. (Courtesy of Karl Ludvigsen.)

This photograph was taken in 1946 at the Almonesson Airport office in Almonesson. The Civil Air Patrol operated from this local airfield. (Courtesy of Stanley Peterson.)

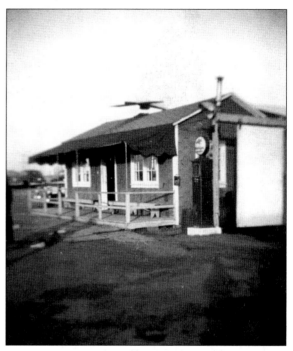

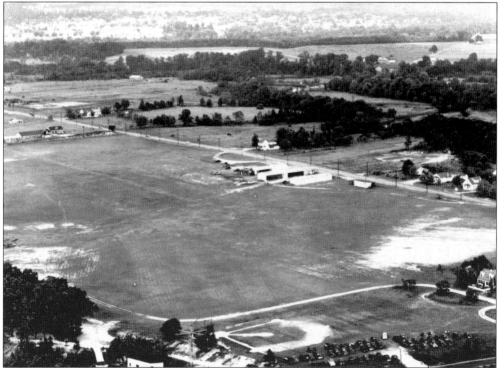

Today, the Home Depot and the Old Country Buffet are located on the site of the old Almonesson Airport along Route 41 (Hurffville Road). The Sunset Beach Park merry-go-round is visible at the lower left-hand corner of this 1948 photograph. Ralph Jones operated the airport. (Courtesy of Karl Ludvigsen.)

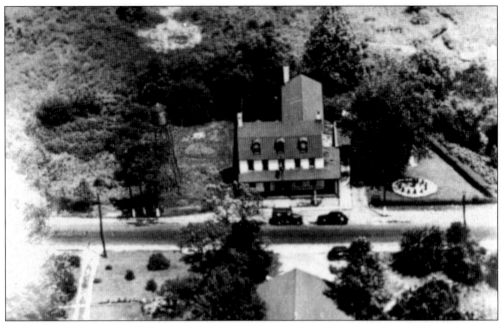

This photograph of the Lake View Inn (formerly the Almonesson Inn) was taken in 1948. The inn can be traced back to before 1750 as a stagecoach stop. It was enlarged in the early 1920s, and a hardwood dance floor was installed. Rooms were rented at the inn as late as the mid-1950s. (Courtesy of Karl Ludvigsen.)

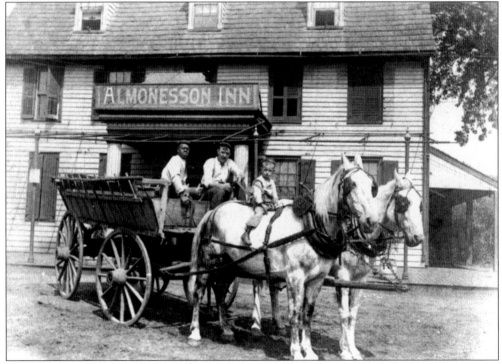

This photograph of the Lake View Inn was taken between 1895 and 1905. In 2002, the inn was remodeled and converted to a restaurant called Filomena's. (Courtesy of Karl Ludvigsen.)

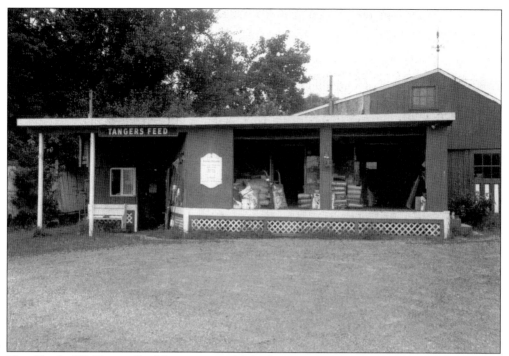

The Charles W. Tanger Feed Store was established in Deptford on Route 41 in 1932. The store is now run by Charles R. Tanger, a second-generation proprietor. (Courtesy of Judy Tanger.)

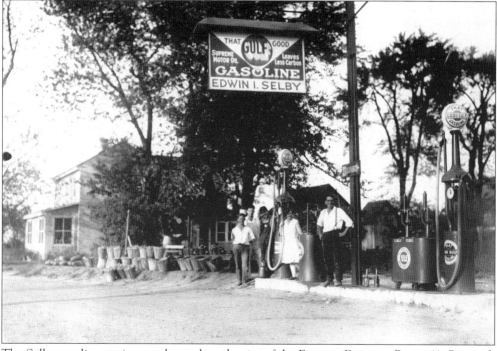

The Selby gasoline station was located on the site of the Freeway Diner on Route 41. Pictured, from left to right, are Edwin, unidentified, Norman, Lydie, and Edwin I. Selby. (Courtesy of John Selby.)

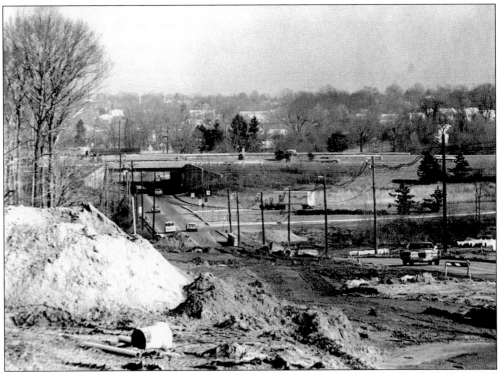

This photograph shows the widening of Clements Bridge Road to prepare for Deptford Mall traffic in 1974. (From the collections of the Gloucester County Historical Society, Woodbury, New Jersey.)

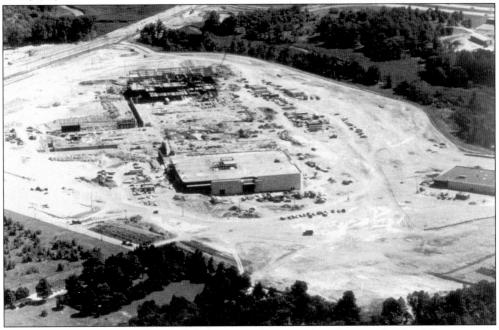

The construction of the Deptford Mall in 1974 is shown in this photograph. The following year, 190 stores opened in the mall. (Courtesy of the Courier Post.)

Built in 1926, the Lewis home (formerly the first Community Volunteer Fire Company), at the corner of Tanyard and Woodbury Lake Roads, is still inhabited by descendants of the family. When it was converted to a home, the Lewis family had windows installed in the front of the house where the fire engine bays had been. (Courtesy of Gladys Pierson.)

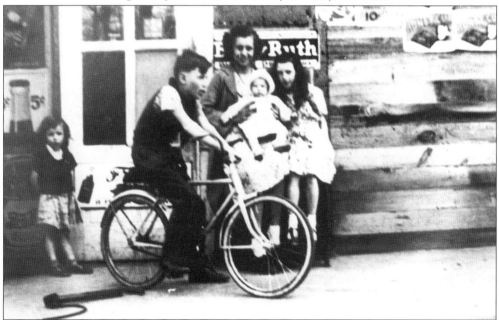

Howell and Gladys Lewis opened a store on the ground level of their home, which had been totally renovated when the fire company moved out. Mrs. Brenner, the township tax collector, set up a table in the store to collect property taxes from local residents. Howell Lewis was politically active, and Lewis Avenue in Gardenville Center was named for him. The store was closed in 1950 but remained a residence for the Lewises' grandchildren. (Courtesy of Gladys Pierson.)

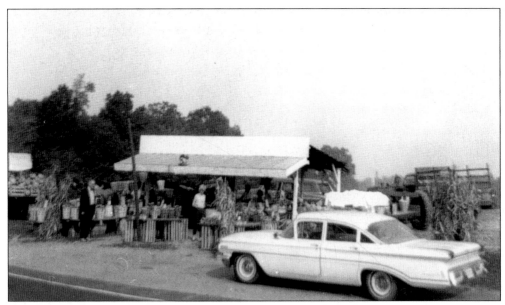

The Andaloro fruit stand operated for many years on Delsea Drive in Westville Grove. (Courtesy of Josephine Andaloro.)

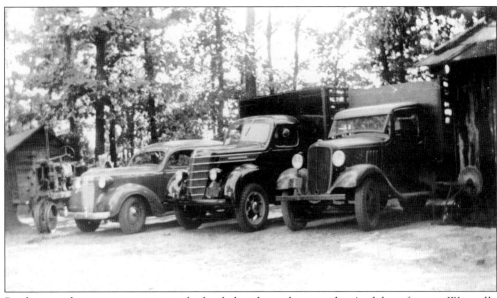

Produce trucks are seen waiting to be loaded with produce on the Andaloro farm in Westville Grove. (Courtesy of Josephine Andaloro.)

A farm worker is shown running a tractor on the Andaloro farm in Westville Grove. (Courtesy of Josephine Andaloro.)

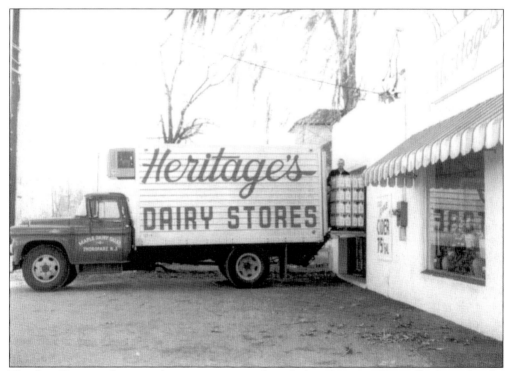

The first Heritage Store in the area was opened on Delsea Drive in Westville Grove by the Heritage family. (Courtesy of Jack Heritage.)

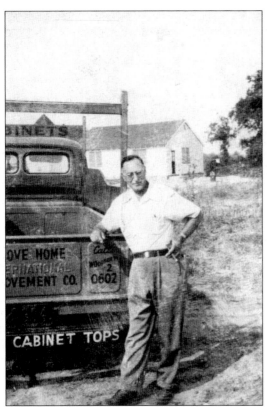

This photograph shows Norton Simon, who started the Grove Home Improvement Company in 1945 with his two nephews. Simon is the grandfather of Paula Stuchel. The business later moved to Delsea Drive and Cooper Street. Only the name of the store has changed; it is still owned by the same family. (Courtesy of Paula Stuchel.)

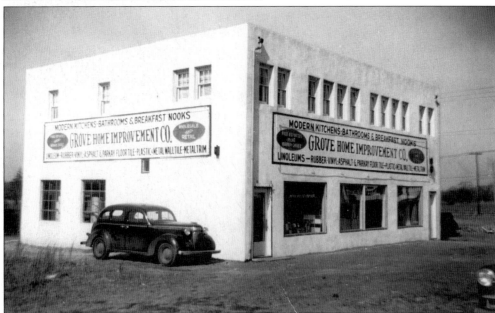

Grove True Value has been a family-owned business since 1945. Originally located in Westville Grove, it was known as the Grove Home Improvement Company. The business moved to Delsea and Cooper in 1949 and was expanded to include retail materials. In 2002, the name was changed to Grove True Value. (Courtesy of Paula Stuchel.)

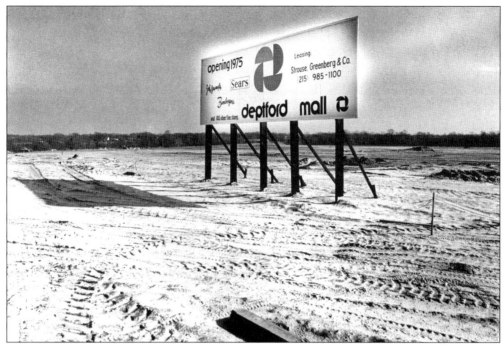

This sign announcing the construction of the Deptford Mall was located in a vacant field at the corner of Clements Bridge and Almonesson Roads in 1974. (Courtesy of the Courier Post.)

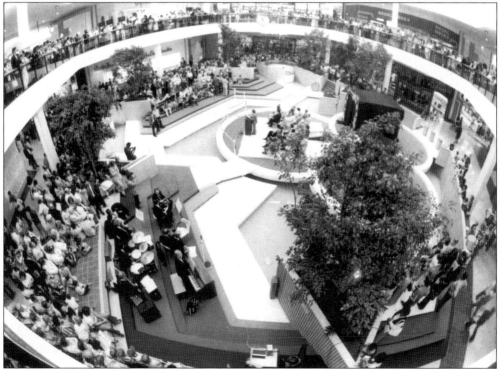

This 1975 photograph shows the grand opening ceremonies for the Deptford Mall. They were held in the center court of the mall. (Courtesy of the Courier Post.)

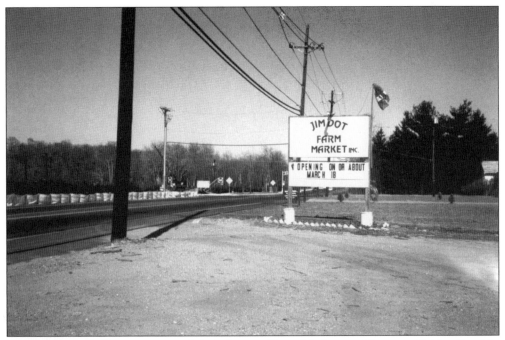

Jim and Carmela Dottavio opened their JIMDOT Farm Market on Clements Bridge Road in 1965. (Courtesy of Sandy Lynch.)

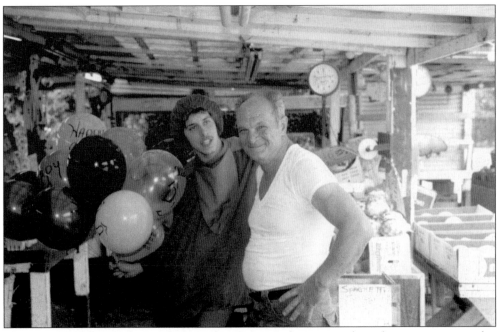

The Dottavio fruit stand was a favorite shopping spot for area residents for many years until it was closed when Clements Bridge Road was widened to accommodate the increased traffic to the Deptford Mall. (Courtesy of Sandy Lynch.)

Three

HOMES

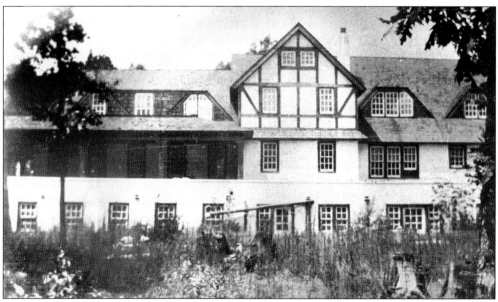

The Oak Valley Country Club is shown as it was *c*. 1935, before Oak Valley became a housing development in the 1950s. It is now used as a residence and is located off Princeton Boulevard. (From the collections of the Gloucester County Historical Society, Woodbury, New Jersey.)

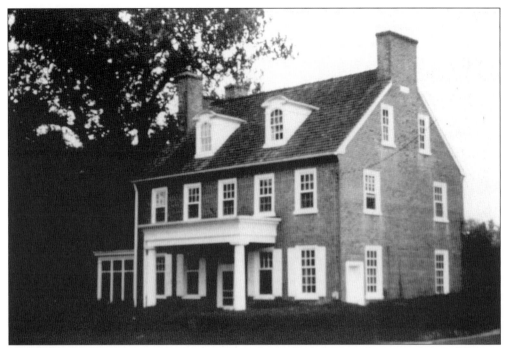

The George Sullivan House, built in 1833, is located on Cooper Street in front of Sunrise Assisted Living Home. (From the collections of the Gloucester County Historical Society, Woodbury, New Jersey.)

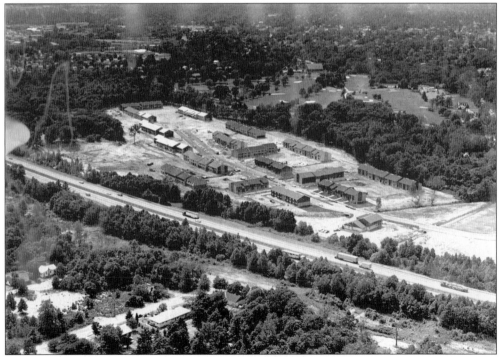

The Stonybrook Apartments on Cooper Street are shown in a 1974 aerial view. (From the collections of the Gloucester County Historical Society, Woodbury, New Jersey.)

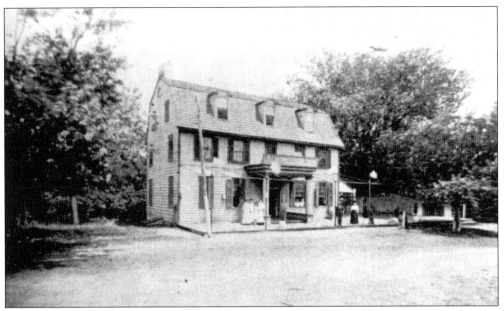

The Lake View Inn, on Cooper Street, was a popular eatery in 1918. At one time, the post office was located in a small room at the left. Pilots from the Almonesson Airport often stayed here. The building is now Filomena's. (Courtesy of Karl Ludvigsen.)

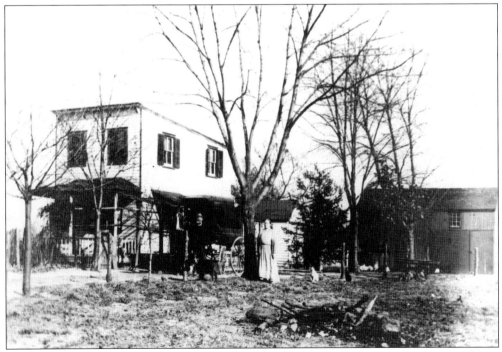

The Martin farm, located on south Delsea Drive in the vicinity of New Sharon, is pictured here in 1918. (Courtesy of John Selby.)

The Gardiner farm was located on Almonesson Road. It is now the site of the Court at Deptford, a popular shopping center. The sycamore tree in the picture remains in the shopping center parking lot. (Courtesy of John Selby.)

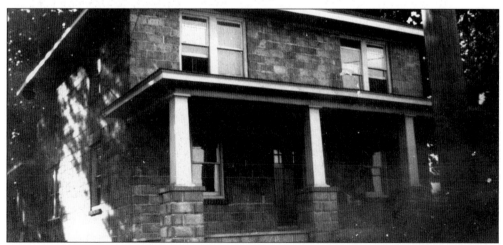

This photograph shows the Andaloro farmhouse in Westville Grove. Harry Eastlack of the First National Bank lent John Andaloro Sr. the money to start the farm soon after the Andaloro family arrived in this country. (Courtesy of Josephine Andaloro.)

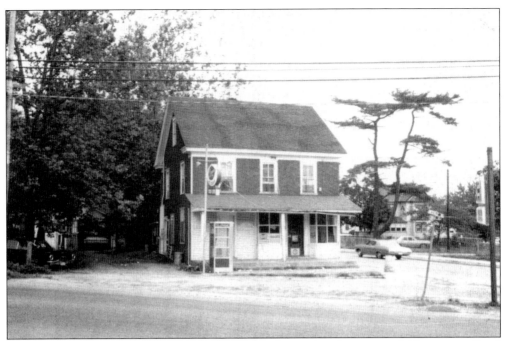

This unidentified store with two apartments formerly stood at the corner of Almonesson Road and Cooper Street and is now a vacant lot across from the Almonesson Lake Firehouse. (Courtesy of John Selby.)

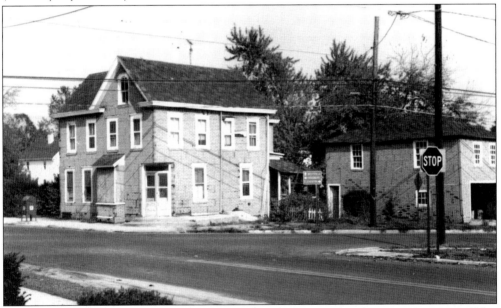

On the opposite corner of the intersection at Almonesson Road and Cooper Street stood this store, which throughout its history served many purposes. During the 1920s, Mart Caulfield ran a general store here. Kerosene was sold from an outside pump. In 1923, it served as a post office where Anna Caulfield served as postmaster. The store later became a butcher shop. Between 1954 and 1964, it again served as the Almonesson Post Office. Wawa operates a convenience store today on this site. (Courtesy of Karl Ludvigsen.)

A view from the Lewis store on Tanyard Road shows the area that is now the New Jersey Turnpike. In the background is the family home of George and Olive Lewis (a different family), located directly across the street from the Community Volunteer Fire Company. Today that house is a Deveraux Group Home. (Courtesy of Gladys Pierson.)

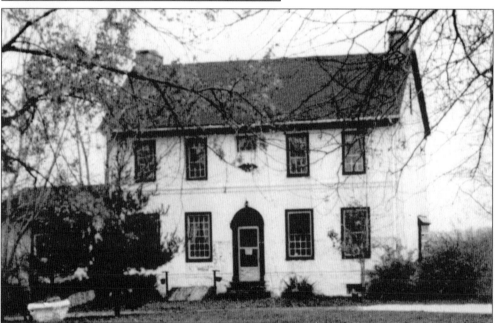

The Nathan Ward House was built on Ward Drive in 1791. According to Lillian Creen, a former owner, there are several rumors about the house that have never been confirmed. One rumor is that the dungeon in the basement was there to restrain slaves or farm workers. Another stated that a tunnel existed, which was said to be part of the Underground Railroad that ran to the James and Ann Whitall House in National Park. (Courtesy of Lillian Creen.)

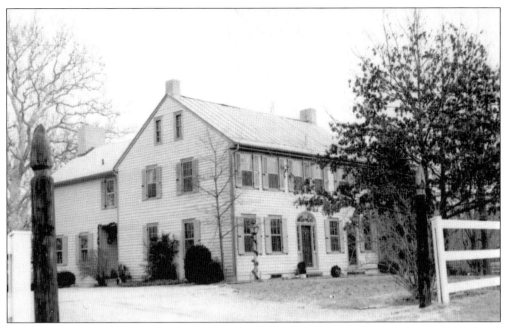

The Pancoast-Moore House is now located on Fox Run Road. It originally stood on Elm Avenue in Woodbury Heights. It was moved in 1951 to make way for the construction of the New Jersey Turnpike. (From the collections of the Gloucester County Historical Society, Woodbury, New Jersey.)

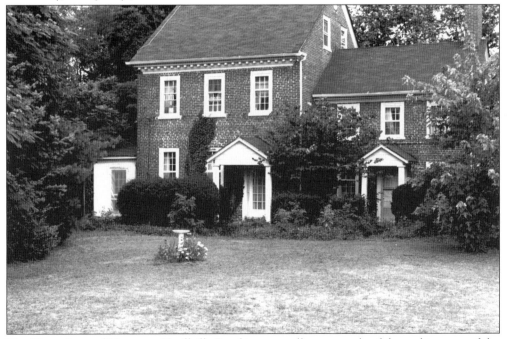

The Pierce-Jaggard House on Hurffville Road is an excellent example of the architecture of the early Federal period. It was built on a hill overlooking Big Timber Creek by Samuel Pierce in 1764. Pierce and his wife, Rebekah, are buried near the house, as was the custom of the time. (Courtesy of Robert and Margot McGroarty.)

Shown here shortly after they were constructed are the Narraticon Townhouses, built in 1974 as part of a planned community. The original price of a townhouse in 1974 was $34,900. Two-bedroom apartments rented for $345 to $405 monthly, including utilities, in 1980. (Courtesy of the Courier Post.)

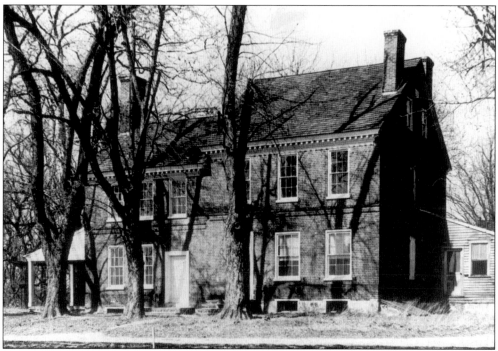

The Benjamin Clark house, located on Woodbury Glassboro Road, was built in 1769 during the Colonial period. In the 1960s, the home was greatly enlarged with an addition and carport. (Courtesy of Margaret Fekete.)

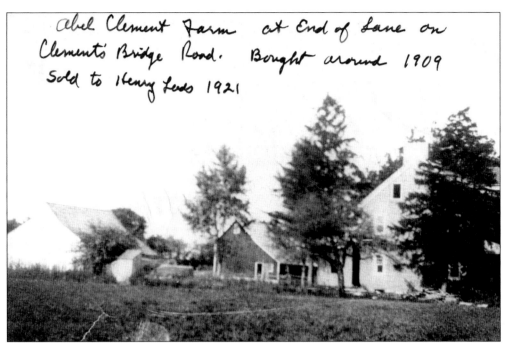

Abel Clement Farm at End of Lane on Clement's Bridge Road. Bought around 1909 Sold to Henry Leeds 1921

The Abel B. Clement farm, pictured here in 1909, was located off Clements Bridge Road. In 1921, it was sold to H.W. Leeds. (Courtesy of Herbert I. Clement Jr. and Judith Clement Hensel.)

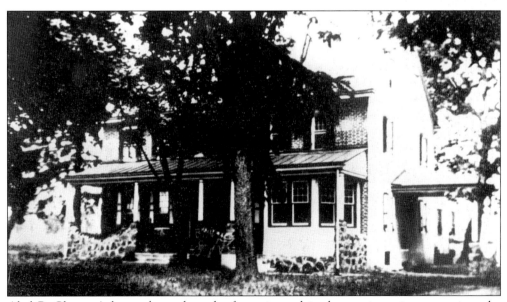

Abel B. Clement's home, located on the farm pictured in the previous view, came into the Clement family c. 1909. It was later purchased by H.W. Leeds and became known as "the West House." (Courtesy of Herbert I. Clement Jr. and Judith Clement Hensel.)

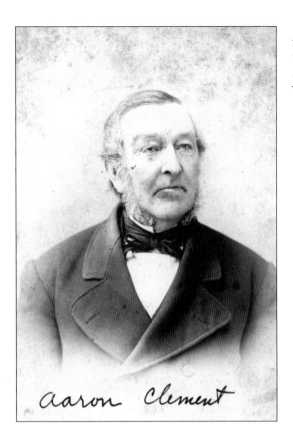

Aaron Clement, husband of Jane Potter Bacon, inherited the Turkey Hill farm in 1840. (Courtesy of Herbert I. Clement Jr. and Judith Clement Hensel.)

aaron Clement

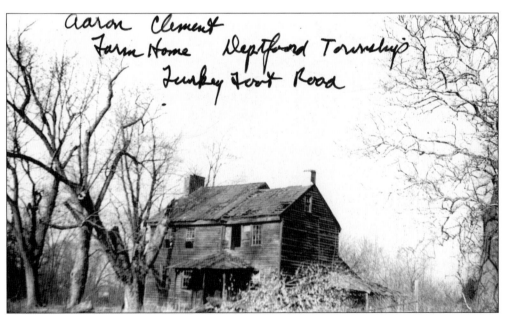

*aaron Clement
Farm Home Deptford Township
Turkey Foot Road*

Shown here is the Turkey Hill farm of Aaron and Jane Clement, who lived here until 1890. The picture was taken after the home was abandoned in the 1930s. (Courtesy of Herbert I. Clement Jr. and Judith Clement Hensel.)

Jane Potter Bacon was married to Aaron Clement. She was born in 1818 and died in 1899. (Courtesy of Herbert I. Clement Jr. and Judy Clement Hensel.)

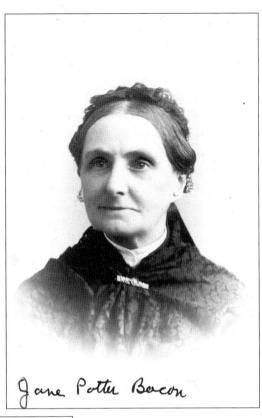

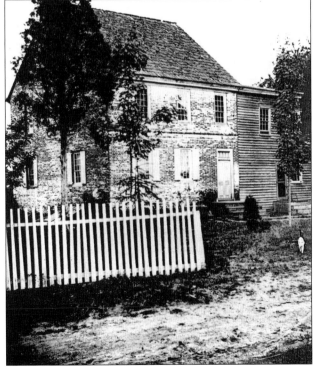

The Timbercreek Farm (also known as the Clement Homestead) was built in 1792 by Abel Clement and his wife, Elizabeth Wills. (Courtesy of Herbert I. Clement Jr. and Judy Clement Hensel.)

AN EXCITING NEW CONCEPT
at an amazing price
in a Split-Level Home

The "William Penn"

for only

$9990

Garage Optional

With Features Available in

$12,000 Homes

- **3 Bedrooms on One Level**
- **Full Basement**
- **Vestibule Entrance**

OTHER FEATURES:

- An Established Community of Homes
- School in the Development
- Public Water and Sewer
- Walls and Ceilings Fully Insulated
- Hardwood Floors
- Copper Pipes
- Large Lots Fully Landscaped
- Guaranteed Roof
- Kitchen Exhaust Fan
- 40-Gallon Hot Water Heater
- 36-inch Gas Range
- Ceramic Tile Bath

**Oak Valley's Own Community Lake
and Beach at Your Doorstep**

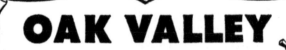

OAK VALLEY

On Route 45, South of Woodbury

DIRECTIONS: Take Route 130 to Woodbury, go through Woodbury to end of Broad Street, stay on left-hand road (Rt. 45) to Oak Valley about 500 yards past Turnpike Bridge. Easily accessible from Benj. Franklin and new Walt Whitman Bridges.

*"An Established Com-
munity of Homes"*

This advertisement for the Oak Valley housing development appeared in the *Oak Valley Observer* in 1959. (Courtesy of John Albert.)

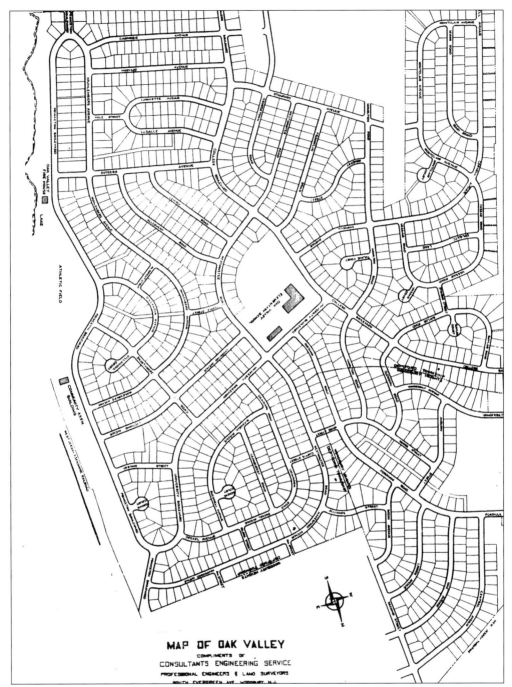

A subdivision map of Oak Valley shows the many curving streets centered around the Oak Valley Elementary School. (Courtesy of John Albert.)

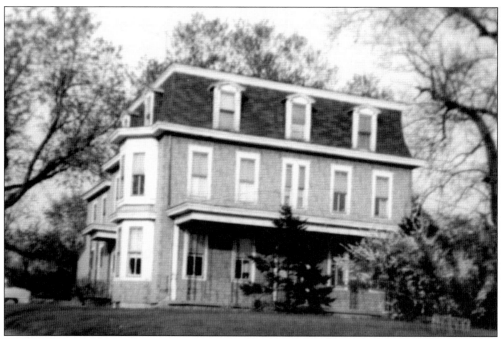

The William Clark residence and farm formerly stood on Caulfield Avenue. This grand house was demolished to make way for the housing subdivision of Locust Grove. (Courtesy of Mary Ellen Colgan.)

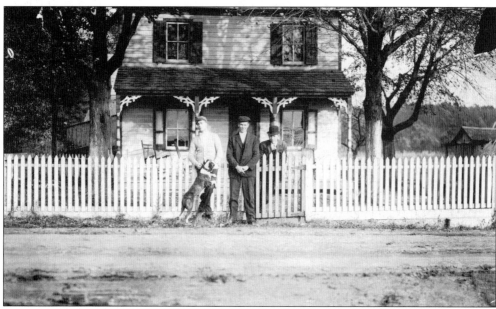

For her entire life, Margaret Colgan lived in this homestead on Delsea Drive in Westville Grove with her four children. This is now the site of the South Jersey Fuel Company, which was Enright Fuel for many years. (Courtesy of Mary Ellen Colgan.)

Four
RECREATION

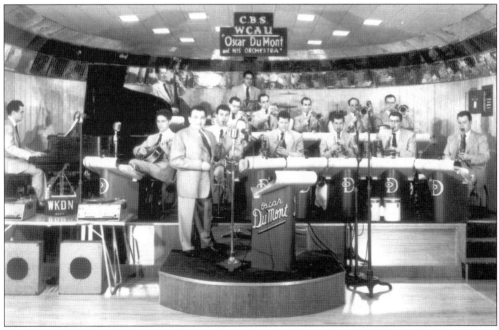

The Oscar DuMont Orchestra often performed at the Sunset Beach Ballroom in Almonesson during the late 1940s. Their performances were broadcast over 27 radio stations from coast to coast. (Courtesy of Karl Ludvigsen.)

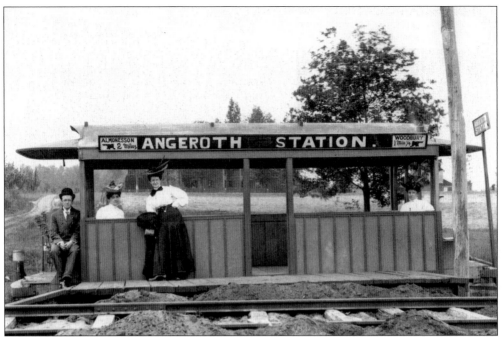

Unidentified people wait for the trolley at the Angeroth Station, which was formerly located on Cooper Street. (From the collections of the Gloucester County Historical Society, Woodbury, New Jersey.)

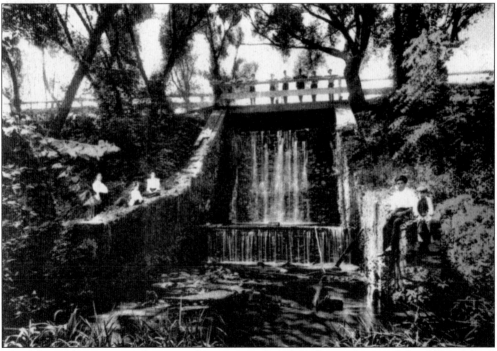

The falls at Almonesson Lake were a favorite meeting place for residents and should bring back fond memories to many people who grew up in Deptford. (From the collections of the Gloucester County Historical Society, Woodbury, New Jersey.)

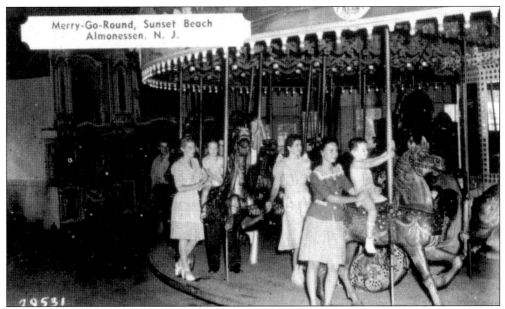

The carousel at Sunset Beach in Almonesson was in service from the early 1940s to the 1960s. (Courtesy of Karl Ludvigsen.)

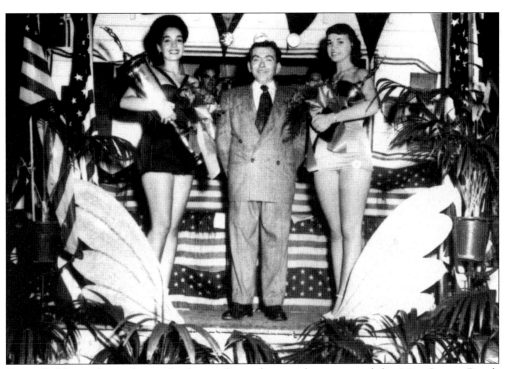

Oscar DuMont, the orchestra leader, is shown here with winners of the Miss Sunset Beach Beauty Contest in 1953. The annual event was held from the late 1940s to the early 1950s. (Courtesy of Karl Ludvigsen.)

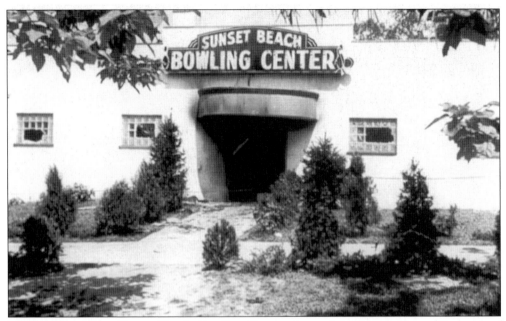

Shown here is the Sunset Beach Bowling Center, located in Almonesson. (Courtesy of Gladys Pierson.).

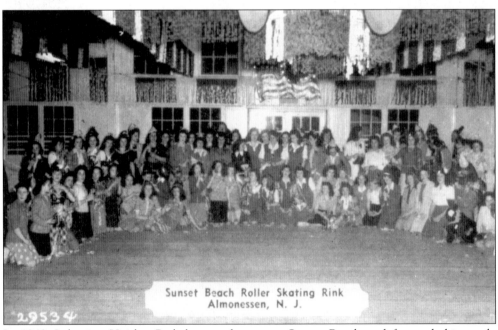

In 1940, Lakeview Heights Park became known as Sunset Beach and featured this newly renovated roller-skating rink. In the 1940s, this building was converted into the Sunset Beach Ballroom. (Courtesy of Karl Ludvigsen.)

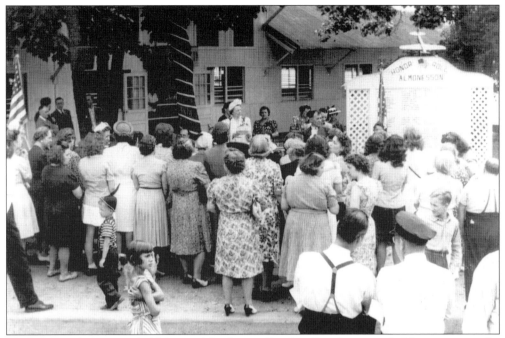

This 1943 gathering was held front of the Sunset Beach roller-skating rink. The woman in the center, wearing a hat, is Clare Caulfield, the wife of Mayor Martin J. Caulfield. (Courtesy of John Selby.)

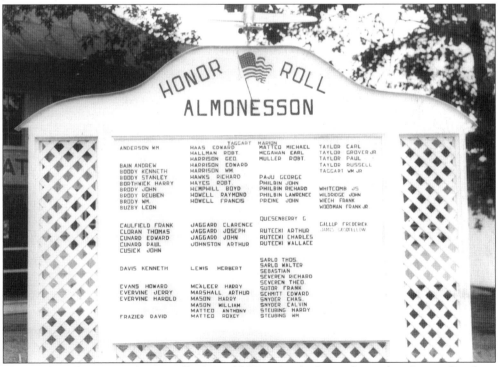

This is the Almonesson honor roll of World War II, which was located at Sunset Beach in Almonesson. (Courtesy of Karl Ludgvisen.)

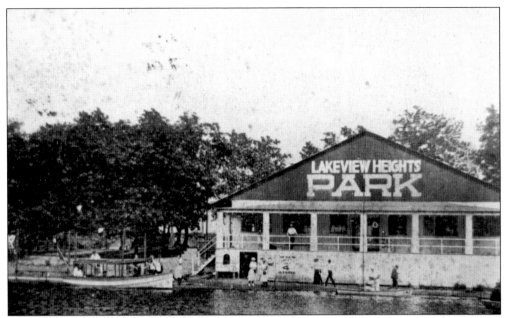

Lakeview Heights Park was later named Sunset Beach. The boat shown in the photograph was used for many years and could carry 20 passengers. It was in operation until *c.* 1925. (Courtesy of Karl Ludvigsen.)

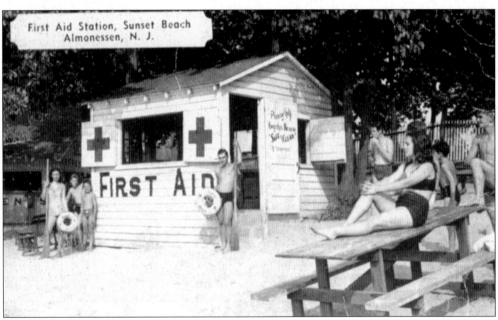

In 1942, when this photograph was taken at Sunset Beach in Almonesson, thousands of visitors were enjoying the park's rental boats and swimming in the summer and the roller-skating center in cooler weather. The lifeguard stand shown here was the favorite meeting place for the young people. (Courtesy of Karl Ludvigsen.)

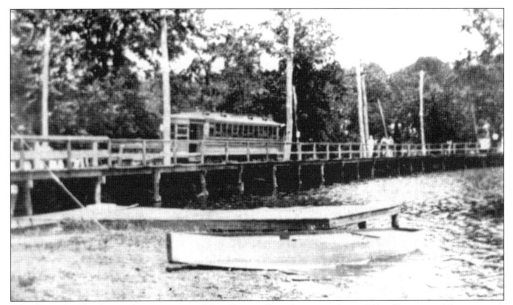

The boardwalk shown here was used by the trolley that ran from Woodbury to Almonesson Amusement Park. This trolley service began on May 29, 1894, and the fare was 10¢. The park had been opened to the public in 1874. (Courtesy of Karl Ludvigsen.)

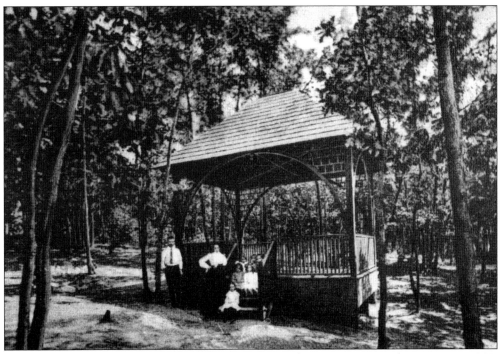

This bandstand was located in the center of Sunset Beach picnic grove in Almonesson in 1908. Many famous bands played here, and outdoor religious services were often conducted on Sunday afternoons by the Almonesson Methodist Church. Elva Wesner played the portable organ, and hymn books were passed out. Many park visitors would join in the service. By 1930, the bandstand was slowly falling apart. (Courtesy of Karl Ludvigsen.)

Narcissa Weatherbee is seen floating at Almonesson Lake's Chicken Beach c. 1945. (Courtesy of Narcissa Weatherbee.)

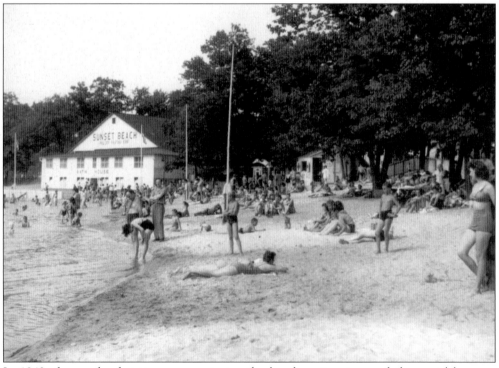

In 1942, thousands of visitors were enjoying the beach, swimming, and the rental boats at Almonesson Lake. (Courtesy of Karl Ludvigsen.)

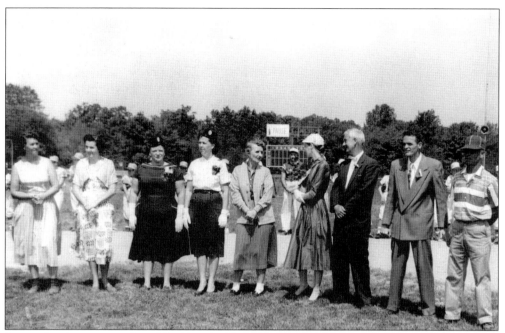

Pictured is the opening day of the Deptford Little League at Taylor Field on Fox Run and Good Intent Roads in the 1950s. The photograph includes Helen Troxel (far left), a Mrs. Snyder (fifth from the left), the mayor (seventh), Deptford Little League president Rich Green (eighth), and Gus Ponto (ninth). (Courtesy of Dick Green.)

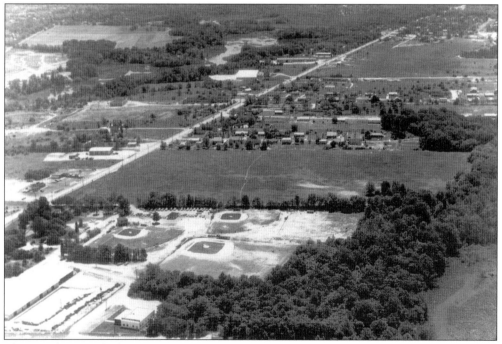

This aerial view of Almonesson was taken between 1965 and 1970. The baseball diamond of the Deptford Little League can be seen in the center. Big Timer Creek is visible in the upper left, and Blenheim is in the background. (Courtesy of Karl Ludvigsen.)

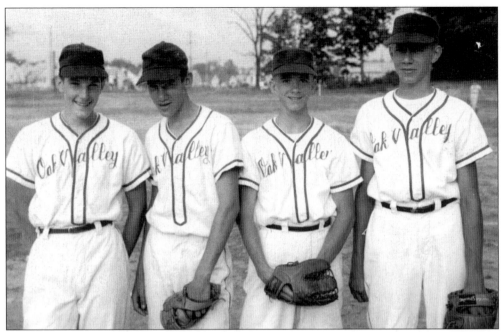

Shown here are four players in the Oak Valley baseball league all-star game in 1961. From left to right are J. Morice, F. Browna, T. Kasper, and R. Schummer. (Courtesy of John Albert.)

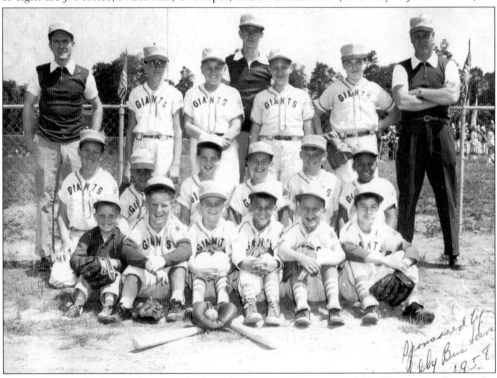

This photograph shows the Deptford Little League Giants in 1958. Known to be in the photograph are Stan Boody Jr., Bruce Rankins, Bob Wolfinger, Bill Busch, and coach Stan Boody Sr. (Courtesy of John Selby.)

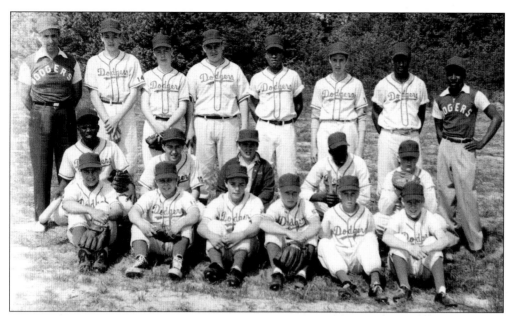

The first year of the Dodgers team in the Deptford Little League was 1955. Al Cunard Jr. was the coach, and Ray Corsey was the assistant coach. (Courtesy of Al Cunard III.)

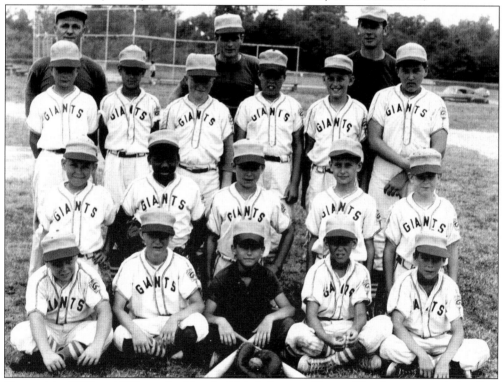

Pictured in 1959 or 1960 are the Deptford Little League Giants. The first row includes Sam Morrone (far left) and Bruce Rankins (fourth from the left). In the third row are Ralph Boucher (second) and Tom Philbin (sixth). In the fourth row are coach Richard Green (second) and coach Jim Van Herrin (third). (Courtesy of John Selby.)

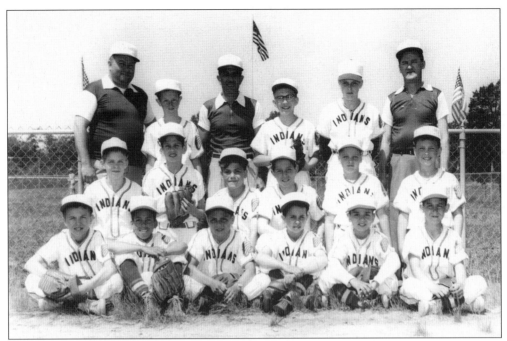

This 1958 photograph shows the Deptford Little League Indians. They are as follows: (front row) Chuck Drive (far left) and Larry Nelson (second from the left); (middle row) Rich Suber (far left); (back row) coach ? Monzo (third) and coach Joe Mason (sixth). (Courtesy of John Selby.)

This photograph shows unidentified umpires of the Deptford Little League. (Courtesy of Dick Green.)

The Deptford Little League Dodgers are shown at their first banquet, held at Moffa's Farm in Blenheim. (Courtesy of Al Cunard III.)

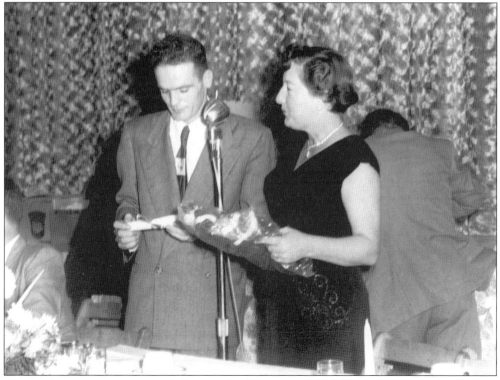

This Little League banquet was held in 1950. (Courtesy of Dick Green.)

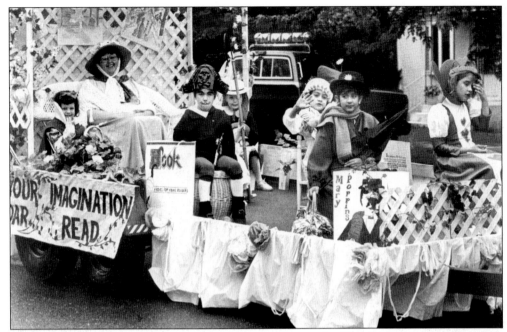

This photograph shows Deptford Public Library's float in the Deptford Day parade in 1994. Seated second from left is Edna Stauffer, a teacher at Lake Tract Elementary School.

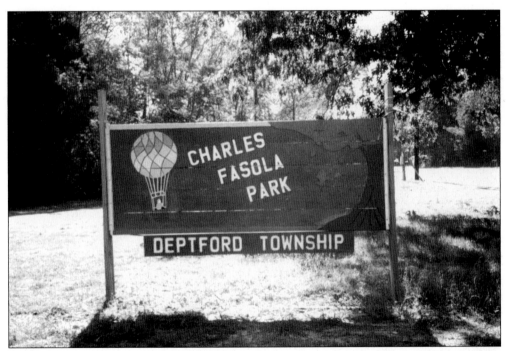

Pictured here is the entrance to Fasola Park on Delsea Drive. Deptford Day is held here every year and offers food, entertainment, and fireworks.

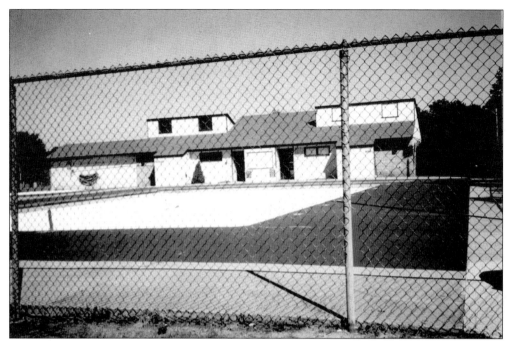
The Fasola Park swimming pool is shown here.

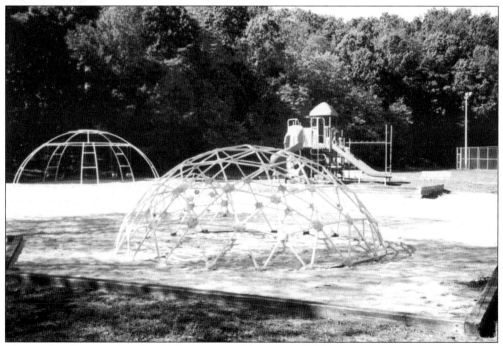
This is the playground at Fasola Park, enjoyed by many children.

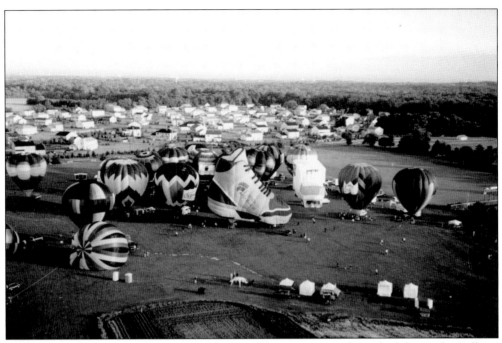

These hot-air balloons are floating over the New Sharon section of Deptford during the Balloon Festival, which is held on the campus of Gloucester County Community College every year. The festivals began in 1994. (Courtesy of Marge Leo.)

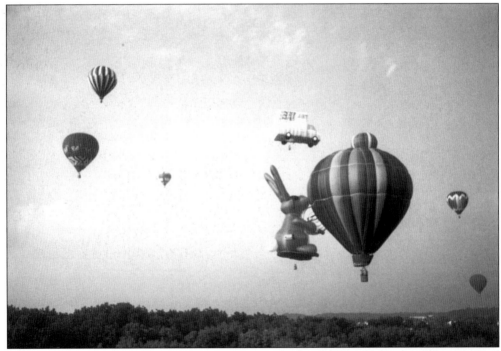

This photograph shows a few of the participants in the first Balloon Festival, held in Deptford in 1994. (Courtesy of Marge Leo.)

Five

POLICE, FIRE,
AND MILITARY

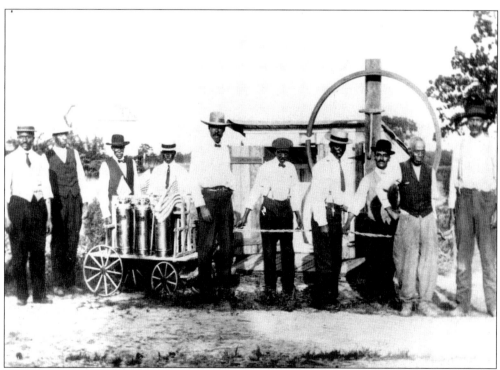

This picture of the Jericho Fire Company was taken in 1921. The cart, with tanks of water, was pulled by the men to fight fires. The tallest one of the 10-man squad was the lead man. The metal ring to the right was hit with a large hammer to alert the firemen and the community. The firehouse stands directly behind the men. (Courtesy of Howard Johnson.)

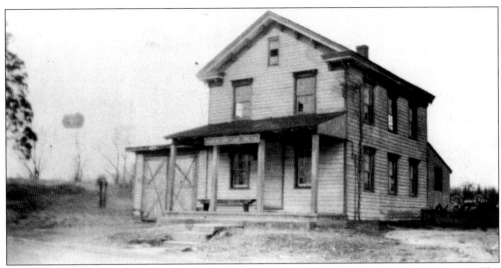

It is believed that this photograph of the Almonesson Lake Firehouse was taken c. 1940. The building was purchased from the Bung Drivers Club on April 13, 1911. The firehouse became the center for the township, and Mr. Eastlack, the town clerk, often sat at the firehouse, recording deeds, registering voters, and so forth. An older man named Casey lived on the second floor and kept a fire going downstairs in cold weather so the truck would not freeze. (Courtesy of Karl Ludvigsen.)

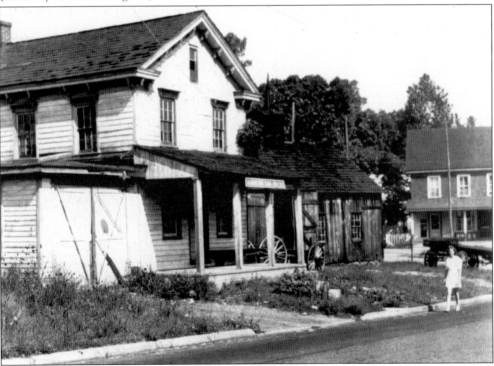

The old blacksmith shop shown here on the right of the firehouse can be traced back to the early 1800s. In 1911, the village blacksmith was George Kindle and the wheelwright was Charlie Davis. Eventually, the property was purchased by the fire company as the site for its new firehouse. The person in the photograph is Ethel Ludvigsen. (Courtesy of Karl Ludvigsen.)

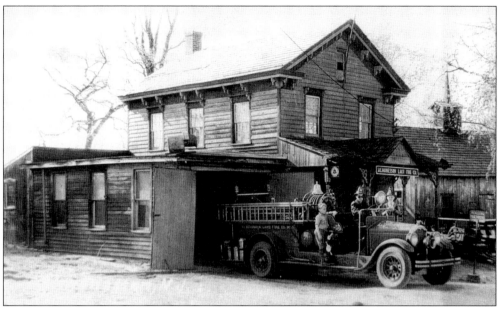

This photograph was taken c. 1926, when this new Buick fire engine was put into service. The Almonesson Lake Fire Company No. 1 was incorporated on February 14, 1911, but had been active before that date and had been housed in a small frame building across from the Lake View Inn. The young boy on the engine is Howard Davis, who lived across the street from the fire company. (Courtesy of Karl Ludvigsen.)

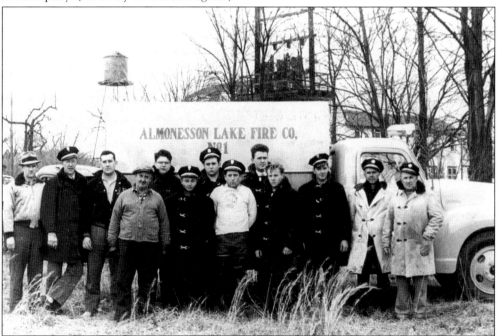

This photograph of the Almonesson Lake Fire Company was taken across from the Lake View Inn c. 1952. From left to right are Karl Ludvigsen, George Hayes, Ken Haines, George Hemphill, Bill McGroaty, Harry Strube, Norman F. Selby, Al Cunard III, Reverend Torgason, Dick Strube, Charles Mason, George Champion, and George Harms. (Courtesy of John Selby.)

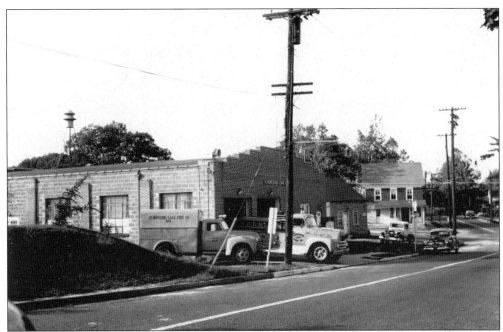

The old Almonesson Lake Firehouse was torn down in 1948. The new firehouse, shown here, was built on the same site and was dedicated on September 27, 1969. (Courtesy of Karl Ludvigsen.)

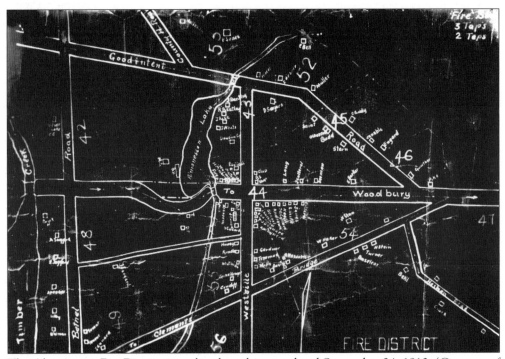

The Almonesson Fire District is outlined on this map dated September 24, 1910. (Courtesy of John Selby.)

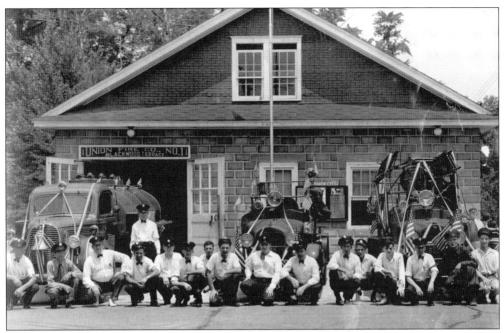

In 1942, this photograph was taken of the Union Fire Company No. 1 outside what was then the company's headquarters on Good Intent Road in Blackwood Terrace. This building replaced one that burned down in February 1932. The tanker shown was built by Charles Leadbeater. The Union Fire Company was established in 1915. (Courtesy of Ellen Massa.)

The Community Volunteer Fire Company, on Tanyard Road, is shown as it looked in the early 1950s. The house on the left, occupied by the Reynolds family, is now the parking lot of the fire company. (Courtesy of Jane Sommers McDermott.)

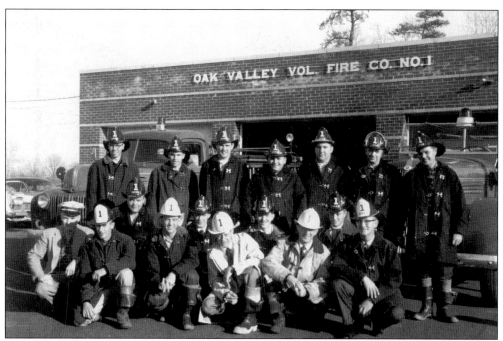

The Oak Valley firemen pose outside the Oak Valley Fire Company No. 1 on Princeton Boulevard in Oak Valley. The firemen were sending holiday greetings to the residents. (Courtesy of John Albert.)

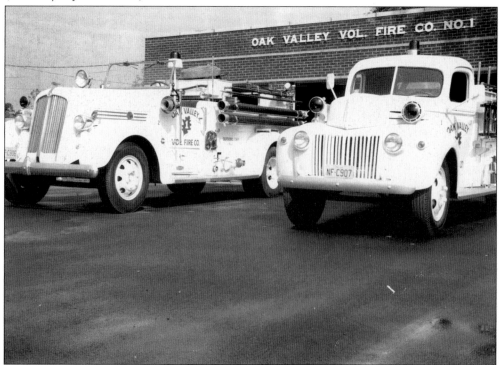

The trucks of the Oak Valley Fire Company are shown in tip-top condition in September 1961. They were painted white at that time. (Courtesy of John Albert.)

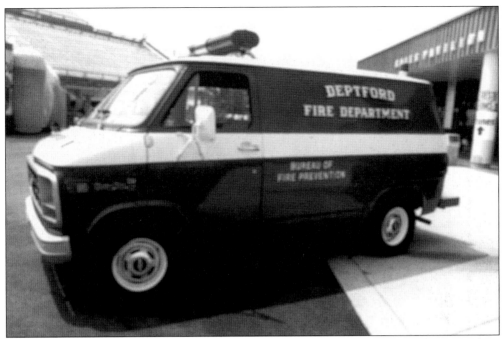

This is a 1981 photograph of the Bureau of Fire Prevention's fire marshal van. Mike Mostovlyan was the fire marshal at the time. (Courtesy of Michele Shorie.)

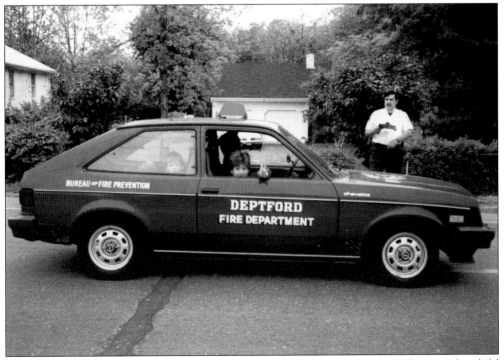

The Bureau of Fire Prevention's fire marshal car is pictured in 1982. Jamie Shorie is the child shown in the front seat, waving to the photographer. (Courtesy of Michele Shorie.)

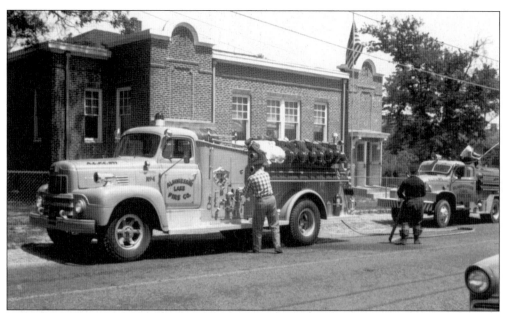

The Almonesson Lake Fire Company conducts a fire drill in front of Almonesson's old two-room schoolhouse in 1954. After the drill, the schoolchildren were taken for a ride on the fire engine. (Courtesy of Karl Ludvigsen.)

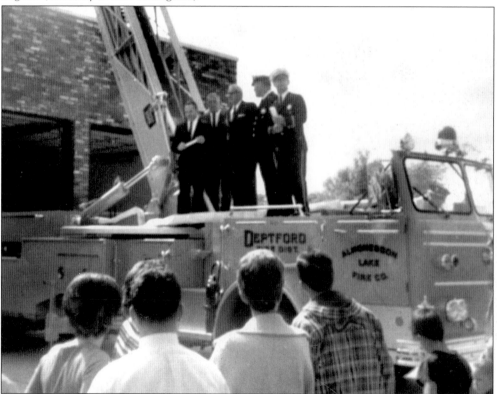

Commissioners and firefighters are shown at the Almonesson Lake Fire Company in 1968. (Courtesy of Michael Gallagher.)

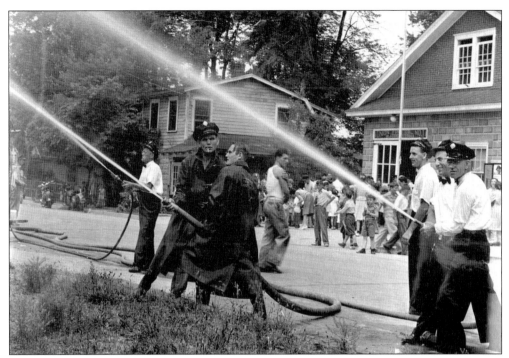

The Blackwood Terrace Fire Company is shown in action during a drill. (From the collections of the Gloucester County Historical Society, Woodbury, New Jersey.)

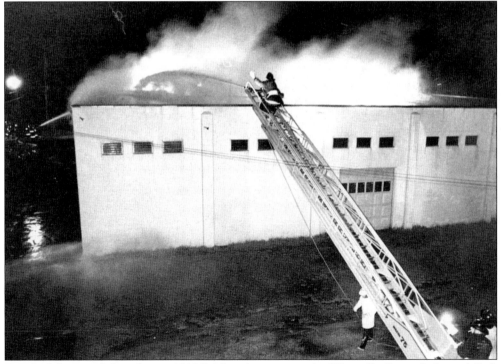

Deptford firemen fight a fire at AVCO Manufacturing in the Westville Grove Industrial Park with a ladder truck. (Courtesy of Michael Gallagher.)

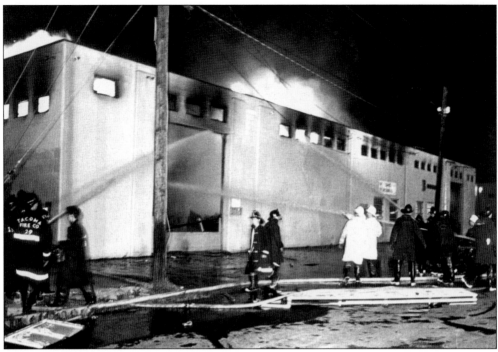

In August 1968, local firefighters can be seen at AVCO Manufacturing in the Westville Grove Industrial Park, working to put out a building fire. (Courtesy of Michael Gallagher.)

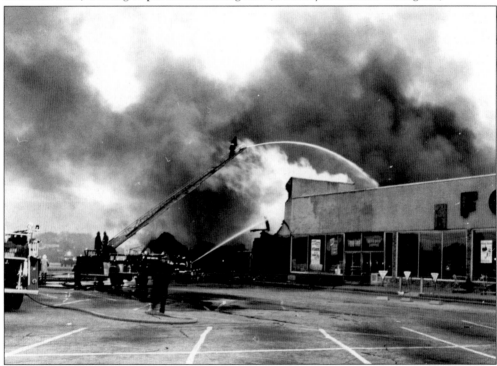

This November 6, 1961 photograph shows a fire at Bargain City, a department store in what is now Deptwood Plaza. (Courtesy of Michael Gallagher.)

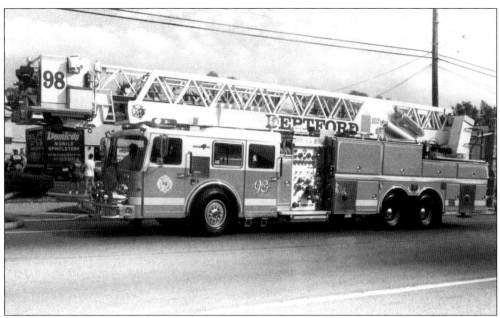

The Deptford Fire Department's first aerial platform truck, purchased for the Almonesson Lake Fire Company, can be seen in this October 6, 1995 photograph. (Courtesy of Michael Gallagher.)

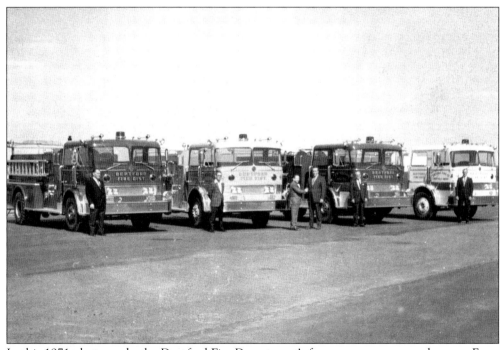

In this 1971 photograph, the Deptford Fire Department's four new pumpers can be seen. From left to right are Harry Crothers, Michael Mostovlyn, Howard "Babe" Leidy, unidentified, John McConnell, and Harold "Bubby" Angeroth. (Courtesy of Michael Gallagher.)

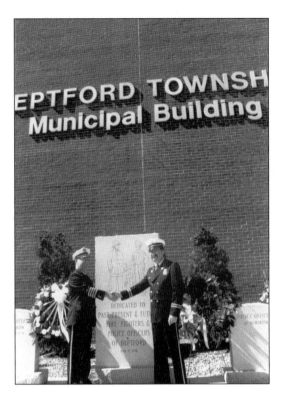

The dedication of the Firefighter and Police Officer Monument in front of the Deptford Township Municipal Building was held on May 17, 1986. Mike Mostovlyn Sr. and Mike Mostovlyn Jr. are shown in the photograph. (Courtesy of Michele Shorie.)

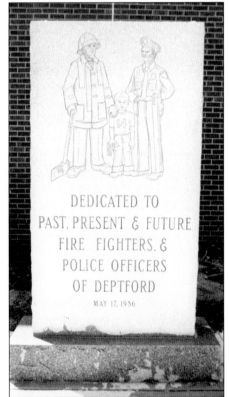

Shown here is a closeup of the monument dedicated to past, present, and future firefighters and police officers of Deptford Township.

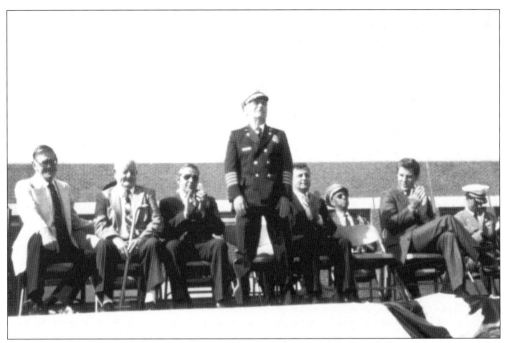

Taken at the dedication ceremonies for the Firefighter and Police Officer Monument, this picture shows, from left to right, unidentified, Andy Snyder, unidentified, Mike Mostovlyn Sr., two unidentified, Jim Florio, and Michael Gallagher. (Courtesy of Michele Shorie.)

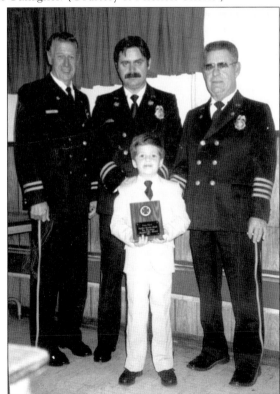

This photograph was taken during Fire Prevention Week ceremonies in October 1985. The winner of an award, Jamie Shorie, poses with George Frazier (left), Mike Mostovlyn Jr., and Mike Mostovlyn Sr. (Courtesy of Michele Shorie.)

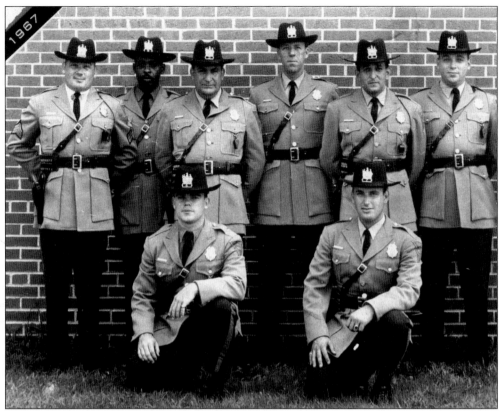

The Deptford Township Police Department started full-time patrols in 1966. This 1967 photograph shows, from left to right, the following: (front row) Steve Moylan and Wayne Quesada; (back row) William Underwood, Milton Miller, Salvatore Vernacchio, Lawrence Ek, Silvio DiCredico, and Joseph Bott. Chief Joseph Michaels and Charles Clifford were not present for the photograph. (Courtesy of Steve Moylan.)

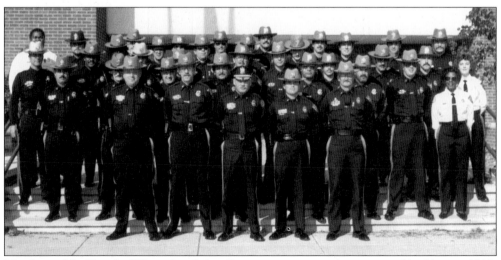

Members of the Deptford Township Police Department pose at the municipal building in 1982. (Courtesy of Steve Moylan.)

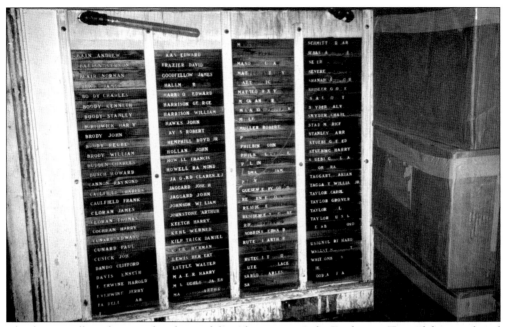

This honor roll used to stand in front of the Almonesson Lake Firehouse. Two of the men listed died in action: Charles Rutecki and John Willridge. (Courtesy of John Selby.)

Bain, Andrew
Batten, Vernon
Blair, James
Blair, Norman
Boody, Charles
Boody, Stanley
Borthwick, Harry
Brody, John
Brody, Rueben
Brody, William
Budden, Charles
Busch, Howard
Cannon, Raymond
Caulfield, Charles
Caulfield, Frank
Cloran, James
Cloran, Thomas
Cochran, Harry
Cunard, Edward
Cunard, Paul
Cusick, John
Dando, Clifford
Davis, Kenneth
Everwine, Harold
Everwine, Jerry
Farrell, Edward
Frank, Harry
Frazier, David

Goodfellow, James
Haas, Edward
Hallman, Robert
Harrison, Edward
Harrison, George
Harrison, William
Hawks, John
Hayes, Robert
Hemphill, Boyd Jr.
Holland, John
Howell, Francis
Howell, Raymond
Jaggard, Clarence
Jaggard, John
Jaggard, Joseph
Johnson, William
Johnstone, Arthur
Keetch, Harry
Kehl, Werner
Kilpatrick, Daniel
Krebs, Herman
Lewis, Herbert
Little, Walter
Marshall, Arthur
Marcus, John
Mason, Harry
Mason, William
Matteo, Anthony

Matteo, Michael
Matteo, Roxey
McAleer, Harry
McLaughlin, James
Megahan, Earl
Menasion, Frederick
Miller, Louis
Muller, Robert
Paju, George
Philbin, John
Philbin, Lawrance
Philbin, Richard
Pidman, William
Preine, John
Quesenberry, Gordon
Residence, John
Residence, Joseph
Residence, Theodore
Riede, Frank Jr.
Robbins, Edward
Rutecki, Arthur
Rutecki, Charles
Rutecki, Theodore
Rutecki, Wallace
Sarlo, Charles
Sarlo, Walter
Schmitt, Edward
Sebastian, William

Severen, Richard
Severen, Theodore
Shanahan, Timothy
Shisler, George
Small, Robert
Snyder, Calvin
Snyder, Charles
Stad, Maurice
Stanley, Harry
Stuebing, Fred
Stuebing, Harry
Stuebing, William
Sutor, Frank
Taggart, Marrian
Taggart, William Jr.
Taylor, Carl
Taylor, Grover
Taylor, Paul
Taylor, Russell
Venable, Raymond
Willridge, John
Usignol, Richard
Wallston, Robert
Whitcomb, John
Wiech, Frank
Woodman, Frank

This 1942 photograph shows members of the Lewis family of Lake Tract with soldiers stationed at a World War II army camp off Egg Harbor Road (now the site of Lake Tract Elementary School). The houses in background were in the area of what is now Tanyard Road. (Courtesy of Gladys Pierson.)

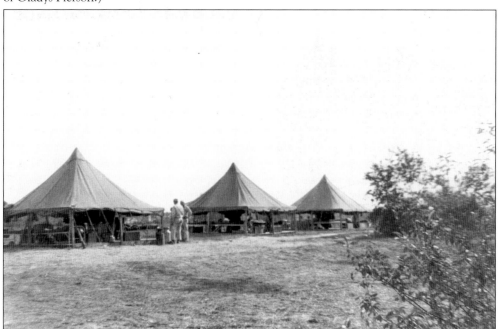

The army camp was a busy place as searchlights flooded the skies and soldiers trained daily at the camp until the end of the war. Neighbors helped the soldiers with laundry, and the soldiers would often congregate at the Lewis family store to use the public telephone and to socialize. (Courtesy of Gladys Pierson.)

This photograph shows a soldier sitting at a communications station at the army camp in the Lake Tract area. (Courtesy of Gladys Pierson.)

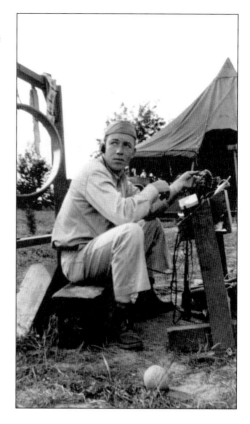

A soldier from the army camp poses for the photographer. The house in background, above the soldier's head, is currently owned by the Devereux Group and is directly across Tanyard Road from the Community Volunteer Fire Company. (Courtesy of Gladys Pierson.)

Pauline Cramer, a member of the Victory Corps, stands in front of an honor roll at Westville Grove School. (Courtesy of Josephine Andaloro.)

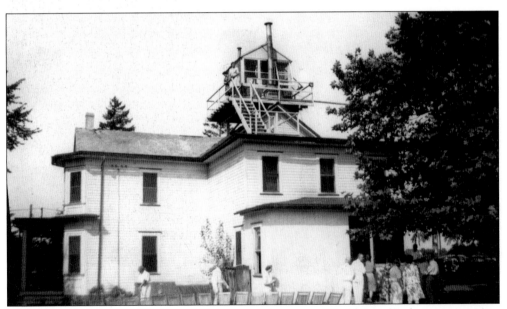

High atop this house in Blackwood Terrace can be seen a World War II observation point. (From the collections of the Gloucester County Historical Society, Woodbury, New Jersey.)

Six

COMMUNITY

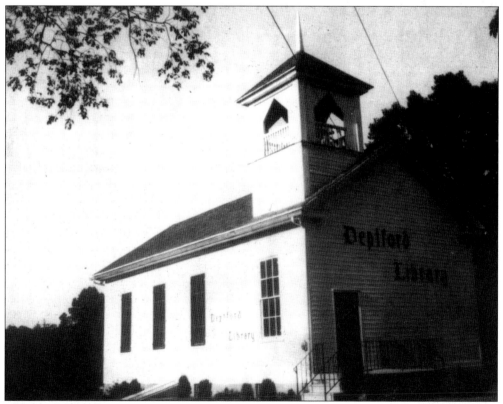

The Deptford Public Library was previously housed in this old Almonesson church building before moving to Ward Drive in the Lake Tract section of the township. In 1961, this old building was moved from its site to its present location to be used by the library until 1981. It is now used by the Boy Scouts.

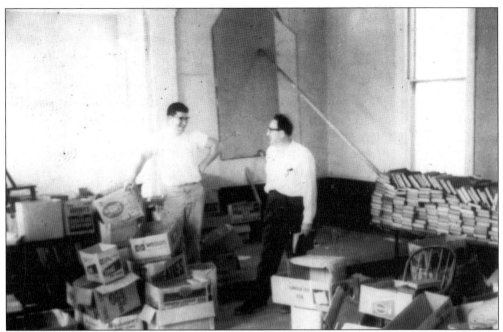

Charles Worth (left) and Edward Rosinski are shown cleaning out the old church so that improvements can be made for the Deptford Public Library to use the building. Renovations began in 1963.

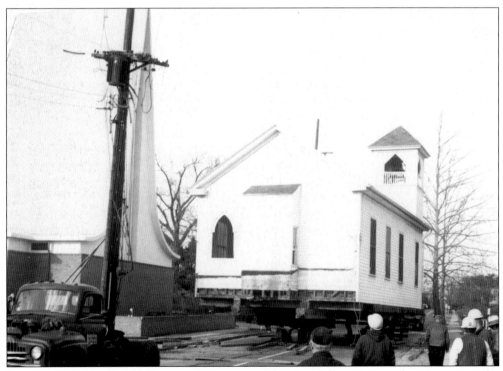

In 1961, this 100-year-old church building was moved, by night, to its new location across the street, where it would be used by the Deptford Public Library. (Courtesy of Karl Ludvigsen.)

The old Almonesson Methodist Church is shown in the background at its original location. The child is unidentified. (Courtesy of Karl Ludvigsen.)

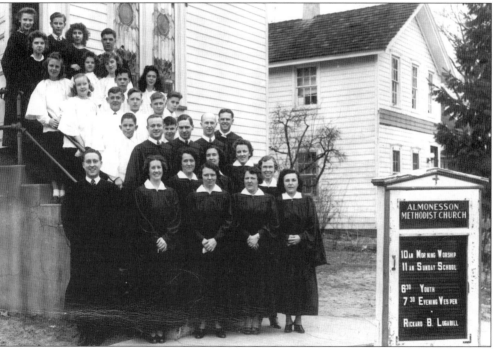

The church choir of the first families of Almonesson are shown here in 1944. Known to be in the photograph are Reverend Lugahill, Marguerite Gardiner, Nettie Davis, Elva Cunard, Laura Bassler, Edna Herr, Bertha Moore, Ruth Vaughn, Elva Wesner, Norman "Snorts" Vaughn, Morris Wesner, Ed Pollitt, Emerson, Bill Reichner, George Moyer, Freddie Brewer Jr., Lee Coulter Jr., Fred Bohler, Jack Coulter, Mary Elizabeth Mason, Ludom Renard, Dorothy Snyder, Georgimae Arnold, Jackie Hessington, Lydia Chew, Alice Reichner, Andrew Hessington, ? Jaggard, Art Little. (Courtesy of Al Cunard III.)

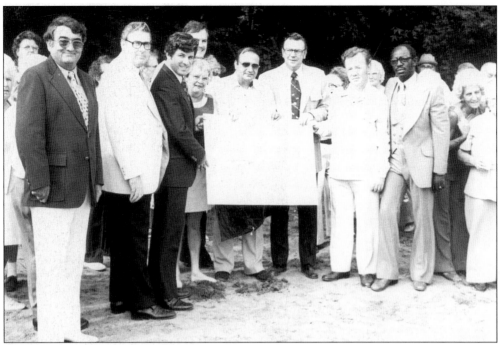

The Deptford Township Council is shown here at the groundbreaking for the new municipal building in 1978. From left to right are Manager James T. O'Neil, John Tull, Gov. James Florio, John Sikking, Sarah Baker, Charles Fasola, Ron Marks, James McGratten, and Robert Carter. (Courtesy of John Tull.)

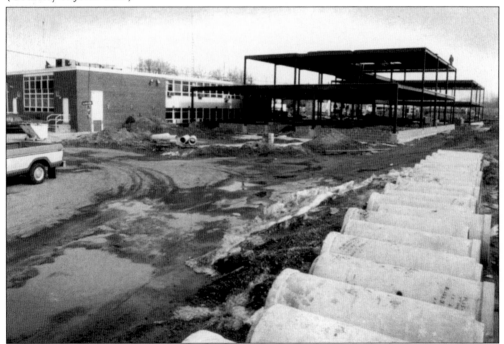

The new municipal building takes shape next to the old building on Cooper Street in February 1978. (Courtesy of the Courier Post.)

Sarah (Sally) Baker, elected to the Deptford Township Council in 1967, was the first woman to be elected to any council in Gloucester County. Shown with her in this photograph is Sen. Thomas Connery. (Courtesy of Sarah Baker.)

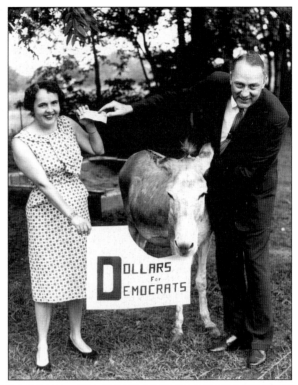

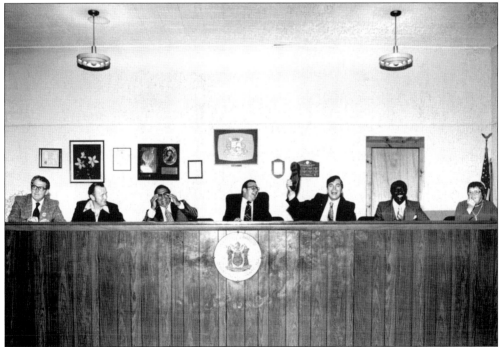

The Deptford Township Council is shown in the old township building c. 1975. From left to right are John Tull, James McGratten, Charles Fasola, Mayor Ron Marks, Jack Sikking, Robert Carter, and Sarah Baker. (Courtesy of John Tull.)

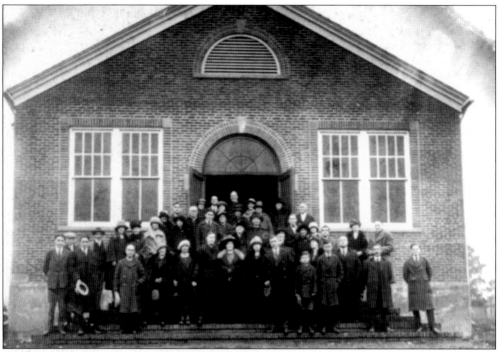

The old St. Agnes Church in Blackwood Terrace was built shortly before 1920 and was rebuilt in 1938 after being destroyed by fire. (Courtesy of Karl Ludvigsen.)

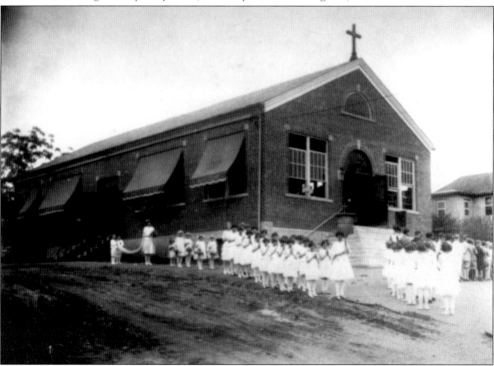

The old St. Agnes Church, now known as St. John Vianny, was destroyed by fire in 1937. This photograph was taken in 1924. (Courtesy of Karl Ludvigsen.)

This is a picture of the old Wesley Methodist Episcopal Church, which was located on Egg Harbor Road in Jericho. A fire occurred sometime in the 1960s. (Courtesy of Alfred S. Coy.)

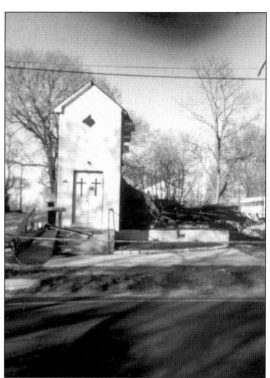

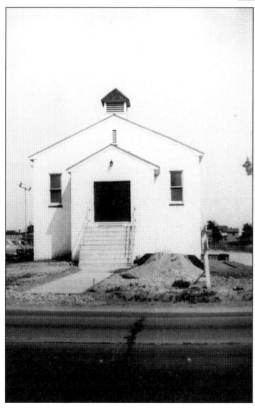

The North Baptist Church is located on Evergreen Avenue in Deptford. (From the collections of the Gloucester County Historical Society, Woodbury, New Jersey.)

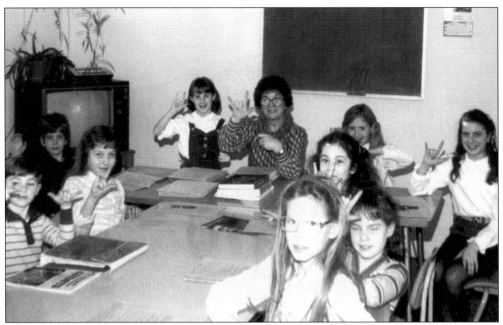

Eleanor Rogers, the library secretary who retired in 1992, instructs local children in sign language at the Deptford Public Library in the late 1980s.

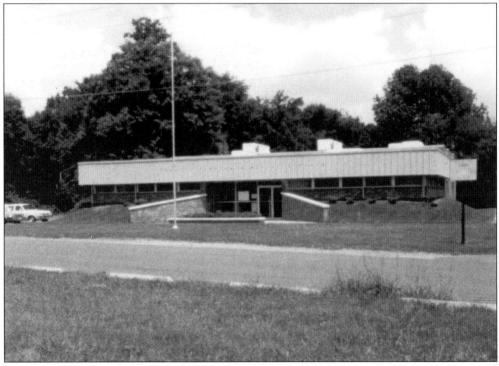

The Deptford Public Library, known for several years as the Johnson Memorial Library, moved from its home in the old church building in Almonesson to the township's community center in Lake Tract in 1981. This 1992 photograph shows the library before it was renovated and enlarged in 1998.

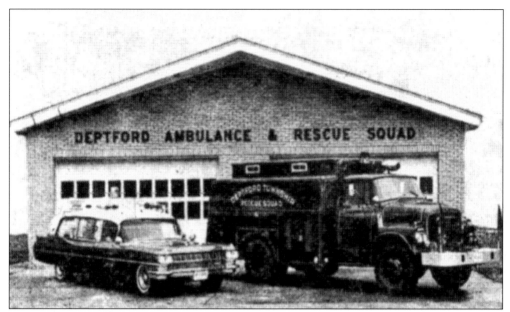

This photograph shows the Deptford Ambulance and Rescue Squad on Good Intent Road in Blackwood Terrace. (Courtesy of Josephine Andaloro.)

DEPTFORD
AMBULANCE AND RESCUE SQUAD

Blackwood Terrace • Deptford, N. J.

February 1966

TO THE RESIDENTS OF DEPTFORD TOWNSHIP:

Due to the extreme amount of work involved in answering over 690 ambulance calls in 1965, Deptford Ambulance & Rescue Squad will not make a personal call but is sending you an envelope asking you to mail $2.00 or more for the privileges and help they will be extending to you.

Only through your generous contributions in the past and your continued support will we be able to go forward in our services to you.

DEPTFORD AMBULANCE & RESCUE SQUAD

EMERGENCY PHONE 227-4444

The Deptford Ambulance and Rescue Squad requests donations in 1966. (Courtesy of Josephine Andaloro.)

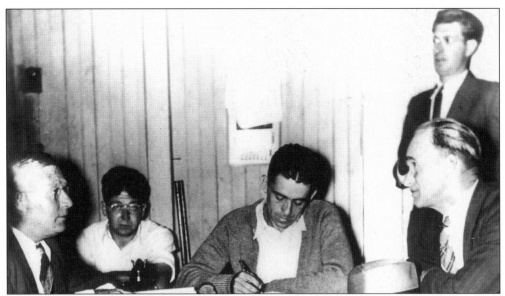

The early fire companies supported themselves by holding carnivals, honey hunts, and going door-to-door. This *c.* 1940 photograph shows one of the mock trials after one of the honey hunts. Al Cunard Jr., court clerk, sits in the center. Norman F. Selby (second from the left) played the part of a farmer who had fired his shotgun to protect his chickens. Louis Kushner stands on the right. When told that it was only a joke, the victims were happy to donate a dollar to help run the fire company. (Courtesy of John Selby.)

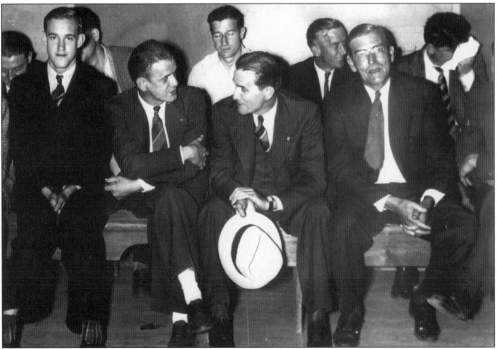

The honey hunts raised a lot of money for the fire companies. These men sitting on benches are waiting to be brought before the judge. After talk of fines and jail, the victims were told it was all a big joke and collections were taken for the fire company. (Courtesy of John Selby.)

Seven

SCHOOLS

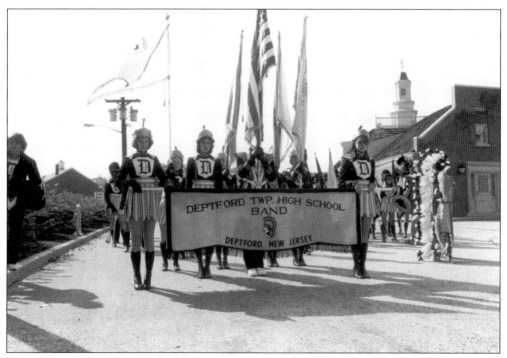

This photograph of the Deptford Township High School marching band color guard was taken in 1978. (Courtesy of Carol Creghan.)

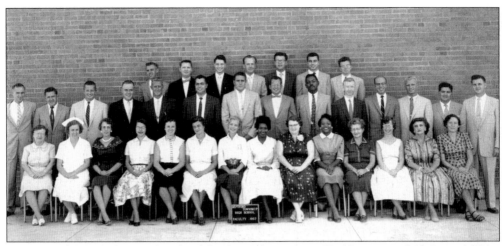

The Deptford Township High School faculty is shown in 1957. (Courtesy of Al Cunard III.)

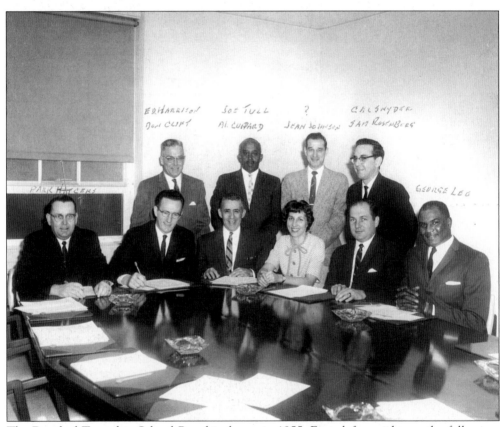

The Deptford Township School Board is shown in 1955. From left to right are the following: (front row) Park Hitchens, Don Clift, Al Cunard Jr., Jean Johnson, Sam Rosenberg, and George Lee; (back row) Ed Harrison, Joe Tull, unidentified, and Cal Snyder. (Courtesy of Al Cunard III.)

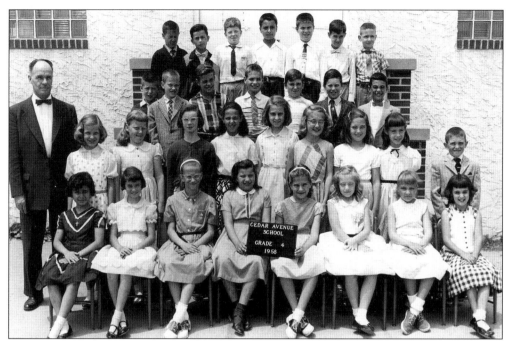

This photograph shows the fourth-grade class of Cedar Avenue School in 1958. This elementary school was located in Westville Grove. The teacher is identified as Mr. McEwen. (Courtesy of Marie Hendrix.)

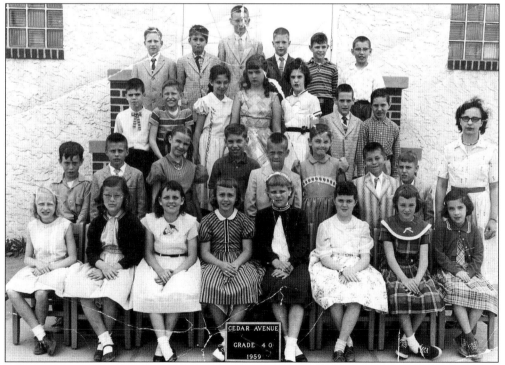

Taken in 1959, this photograph shows the fourth-grade class of the Cedar Avenue School in Westville Grove. Mrs. O'Shore is the teacher. (Courtesy of Marie Hendrix.)

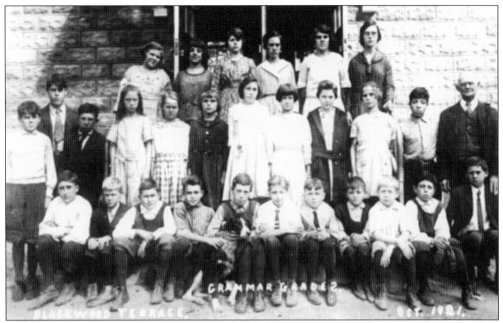

This photograph shows the students in the grammar grades at Blackwood Terrace School in 1921. Norman F. Selby is seventh from the left in the front row. The third person from the left in the back row is Lillian Quesenberry. (Courtesy of John Selby.)

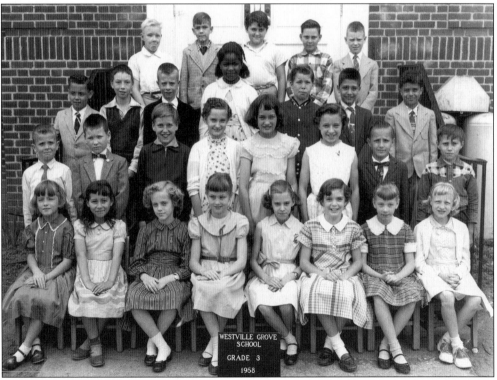

In this 1958 photograph are the third-grade students of the Westville Grove School. (Courtesy of Marie Hendrix.)

Students line up for school buses to take them home on the first day of school in September 1960. They are standing in front of the Oak Valley School. (Courtesy of John Albert.)

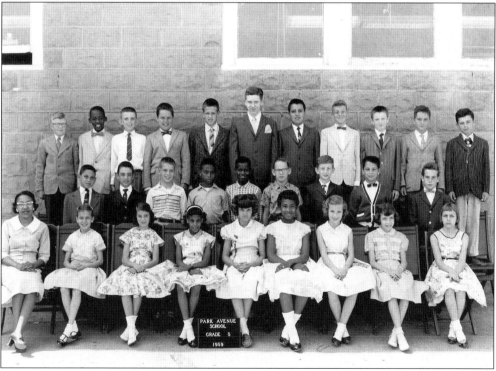

Pictured in 1959 is Miss Jackson's fifth-grade class at the Park Avenue School. (Courtesy of Doris Calloway.)

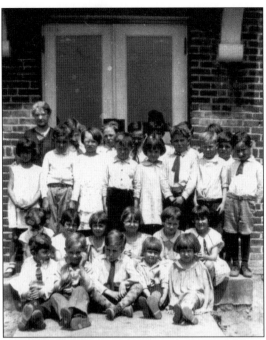

This photograph shows Mrs. Talman's third-grade class at Almonesson School in 1929. (Courtesy of John Selby.)

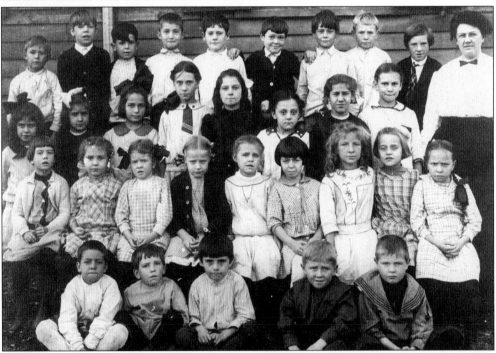

Pictured is the last class to graduate from the original Almonesson School. The old wooden building was moved to Cunard Avenue in 1913, when this photograph was taken. The brick replacement is still standing. Included in the photograph are the following: (first row) Alfred M. Cunard Jr. (third from the left) and Edwin Selby (fourth); (third row) Edith Jones (seventh), Madeline Warwick (eighth), Laura Gieber (ninth); (fourth row) Henry Barnes (fourth) and Harry Timinis (fifth). The teacher is identified as Miss Gibson. (Courtesy of John Selby.)

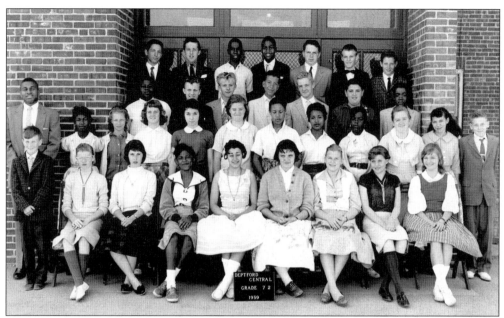

Mr. Hawkins's seventh-grade class at Central School is shown during the 1958–1959 school year. (Courtesy of Karen Countryman.)

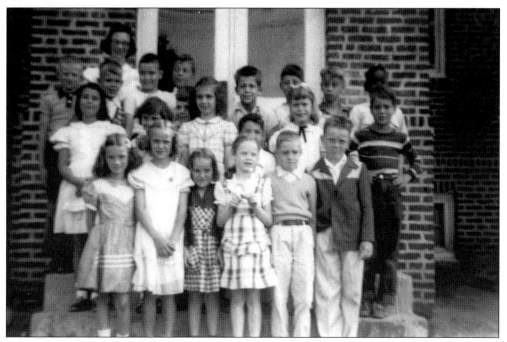

Students at Almonesson School in 1953 or 1954 are as follows: (front row) Linda Breneman (far left), Janet Garrett (third from the left), and Linda Gillespie (fourth); (middle row) Linda Peters (far left), Nancy Drier (fourth), Fred Selby (fifth), and Carol Turner (sixth); (back row) Norman Champion (third), Eddie Nelson (fourth), Richie Hildebrand (sixth), and William Russell (eighth). (Courtesy of John Selby.)

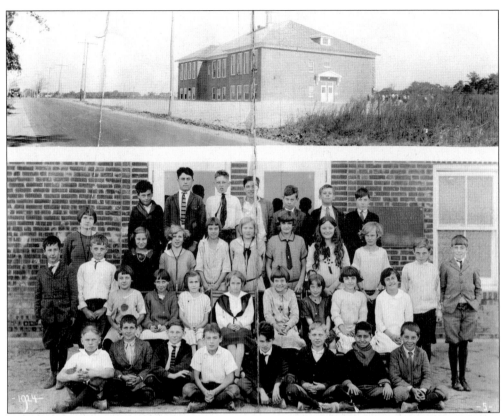

This photograph shows Central School in 1924, before lightning hit the roof. Also shown is the first class entered into the school. (Courtesy of Laura Larsen Tarrach.)

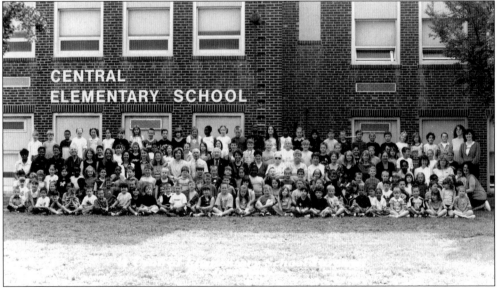

This photograph shows the staff and students of Central School in 2002, the last year the school was open. This school was demolished to make way for a $15 million state-of-the-art early-childhood center to be opened for the 2003–2004 school year. (Courtesy of Geri Richardson.)

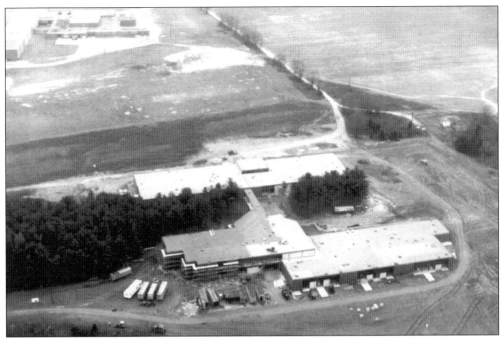

In January 1974, the Gloucester County Vocational School is shown about 70 percent complete. The school was scheduled to open that spring with 1,000 students, offering training in 23 different fields. (Courtesy of the Courier Post.)

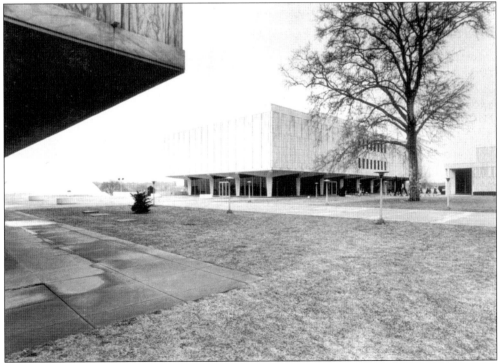

Deptford is the proud home of Gloucester County Community College, as shown here in 1971. (Courtesy of the Courier Post.)

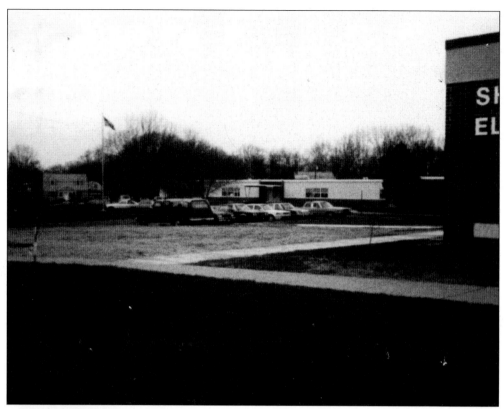

In 1974, a new addition to Shady Lane School in Westville Grove was constructed. (Courtesy of Doris Calloway.)

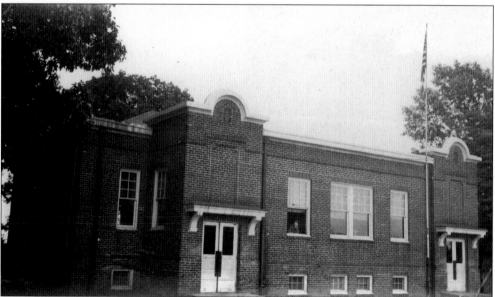

In 1913, this brick building replaced the old wooden Almonesson School. The building still stands on Cooper Street, but it is now used as a medical center. (From the collections of the Gloucester County Historical Society, Woodbury, New Jersey.)

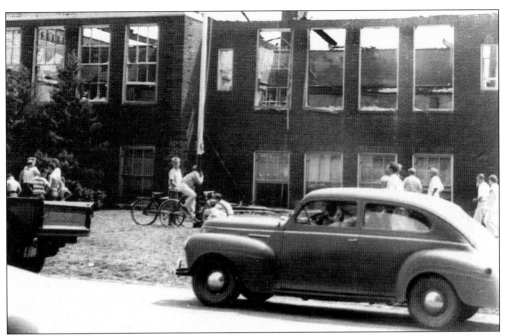

Schoolchildren and parents survey damage from a fire at Central School *c.* 1948. (Courtesy of Jane Sommers McDermott.)

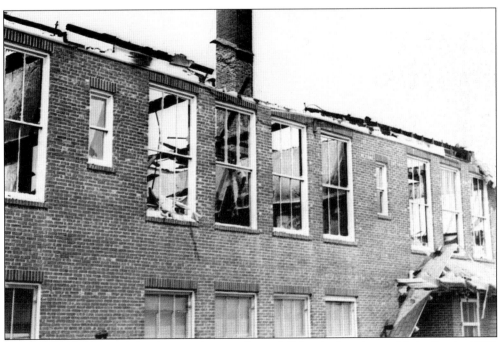

This is another view of the damage done to Central School when it was hit by fire in 1948. (Courtesy of Jane Sommers McDermott.)

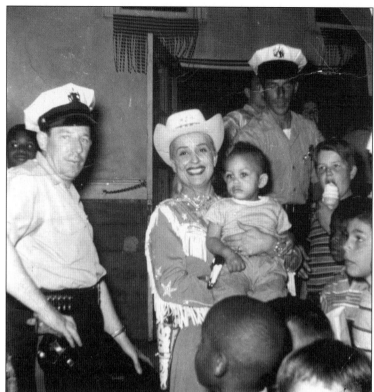

Cowgirl Sally Star, who appeared many times on stage and television, was a local celebrity. She is pictured on a visit to New Sharon's school fair *c.* 1958. The boy she is holding is identified as Larry. (Courtesy of Doris Calloway.)

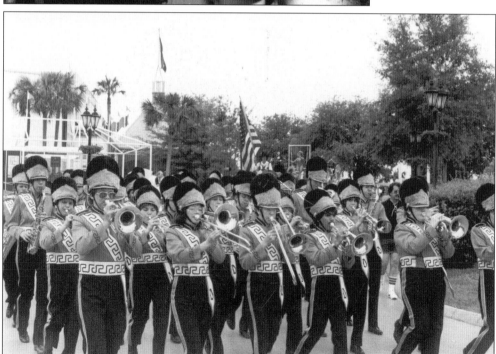

The Deptford Township High School marching band performs at Disney World in the 1980s. (Courtesy of Deptford Township High School.)

The Deptford Township High School marching band is shown marching up Cooper Street in a homecoming parade. (Courtesy of Deptford Township High School.)

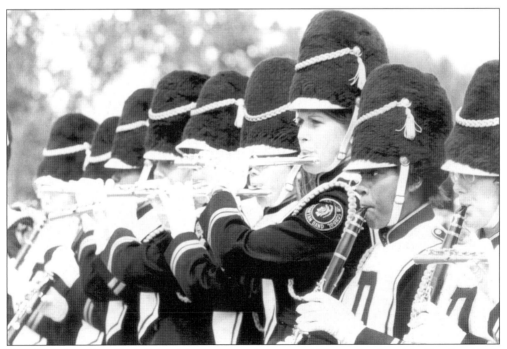

Deptford Township High School had an award-winning 170-member band in October 1972, when they performed at this football game. (Courtesy of the Courier Post.)

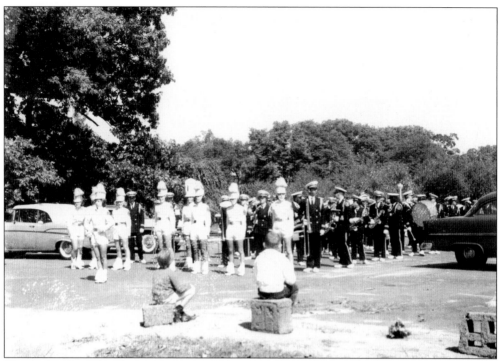

The high-school band prepares for its first competition held at Glassboro State Teachers College (now Rowan University). They had brand-new black-and-gold uniforms, and they won the trophy.

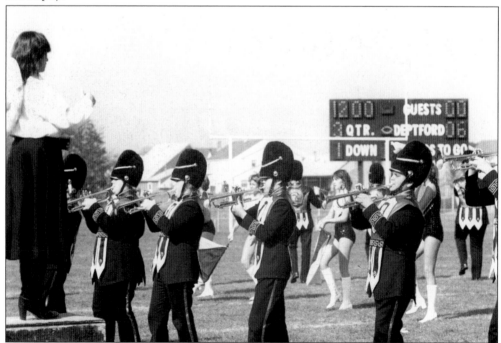

The Deptford Township High School marching band performs in the 1970s. (Courtesy of Deptford Township High School.)

Eight
MISCELLANY

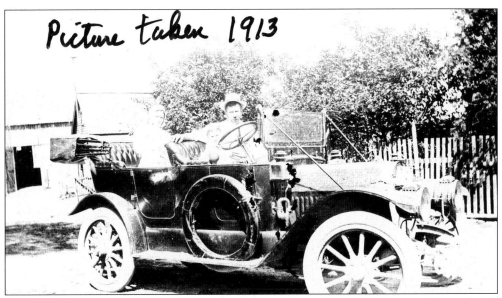

Picture taken 1913

This photograph shows Herbert I. Clement Sr. driving his 1910 Maxwell, purchased secondhand for $1,500. His wife, Lillie, and children Eleanor and Abel are with him for the drive. The family's farmhouse is in the background. (Courtesy of Herbert I. Clement Jr. and Judy Clement Hensel.)

N

Tidal Wetlands

Tidal W

Maple Swamp Wetla

Station #6

Station #7

Station #5

Station #8

Overlook

Station #4

Hill

Station #3

Station #9

Station #2

Station #1

Royal Motors

Parking Area

Timber Creek Pa
Trail Map

Route 41/Hurffville Road

This map of the trails at Timber Creek Park was taken from a guide produced by the Deptford Township Environmental Commission. (Courtesy of Joan Tracy.)

112

Pictured is the sign welcoming people to the Old Pine Farm Natural Land Trust, located on Pine Avenue in Blackwood Terrace. (Courtesy of Joan Tracy.)

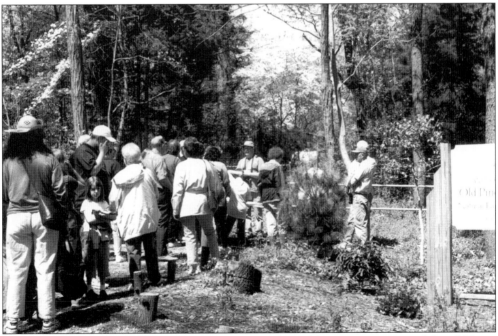

In this photograph, visitors are taking a tour of the Old Pine Farm Natural Land Trust. (Courtesy of Joan Tracy.)

This 1977 aerial photograph shows where Delsea Drive intersects with Interstate 295. Inverness Apartments can be seen along the right border of the picture, and Stein's Garage can be seen in the center. Part of the Westville Grove Industrial Park can be seen in the lower part of the photograph. (Courtesy of Ramon Stein.)

This is an aerial view of the intersection of Cooper Street and Delsea Drive. The old Grove Hardware building can be seen on the right, and in the center is the Deptford Township Municipal Building. A newly constructed Cooper Village can be seen in the background. (From the collections of the Gloucester County Historical Society, Woodbury, New Jersey.)

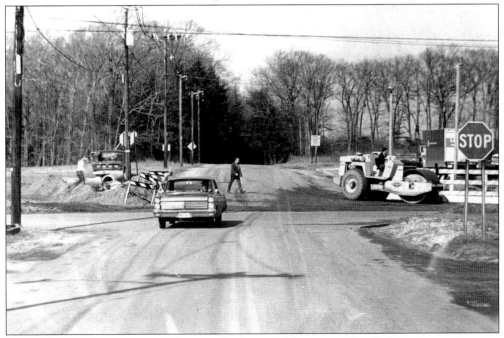

Pictured is the intersection of Clements Bridge and Almonesson Roads. The intersection was being widened in preparation for Deptford Mall construction. (From the collections of the Gloucester County Historical Society, Woodbury, New Jersey.)

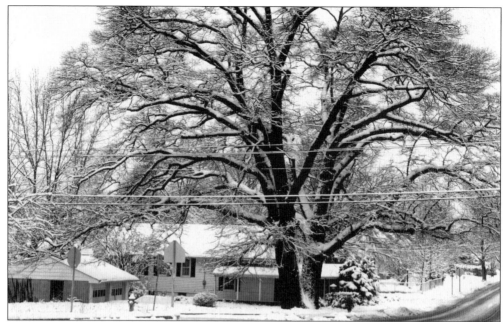

This is a winter picture of the 300-year-old Twin Willow Tree, on the corner of Tanyard Road and Woodbury Lake Road. It is believed the tree was damaged when Woodbury Lake Road was moved to accommodate the construction of the New Jersey Turnpike. (Courtesy of Gladys Pierson.)

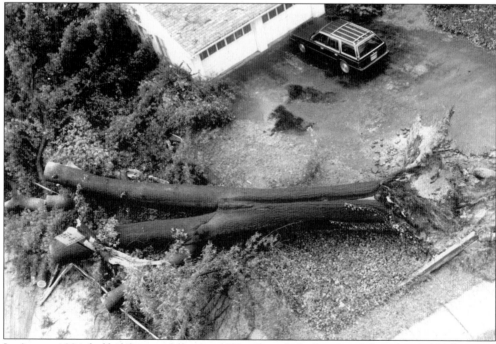

In August 1994, half of the tree fell toward Woodbury Lake Road and the other half fell toward Tanyard Road. These pictures were taken by a utility worker using a camera owned by a member of the family that lived in the house. (Courtesy of Gladys Pierson.)

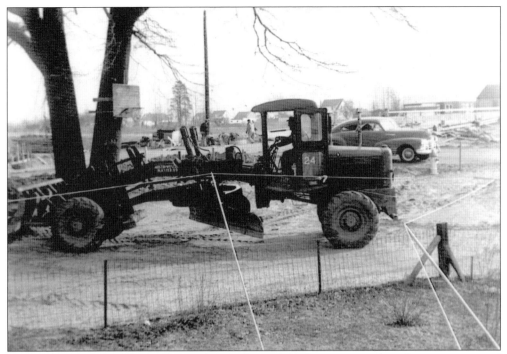

This picture shows how Woodbury Lake Road was moved to accommodate the construction of the New Jersey Turnpike. Earth that was placed around the base of the tree eventually caused decay and damage to the tree. (Courtesy of Gladys Pierson.)

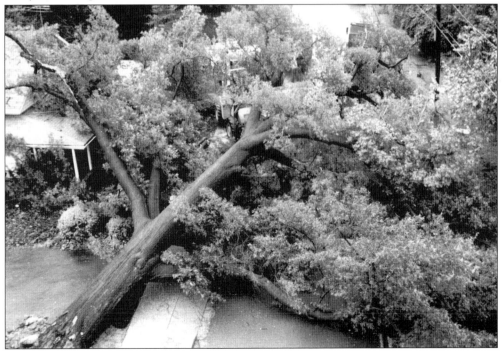

This is the half of the tree that fell toward Tanyard Road. No one was injured, and damage was minimal, considering the size of the tree. (Courtesy of Gladys Pierson.)

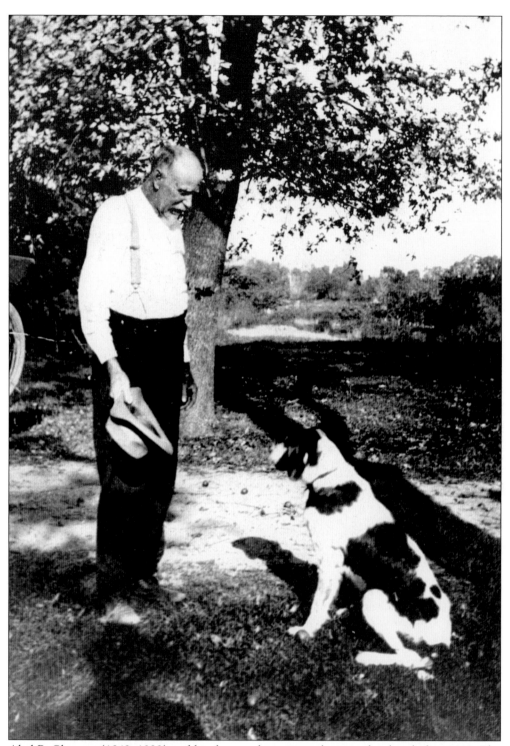

Abel B. Clement (1849–1923) and his dog are shown in a photograph taken before 1910. The water in the background is Timber Creek. Clement married Mary Francis Brewer in 1875, and they had 12 children. (Courtesy of Herbert I. Clement Jr. and Judy Clement Hensel.)

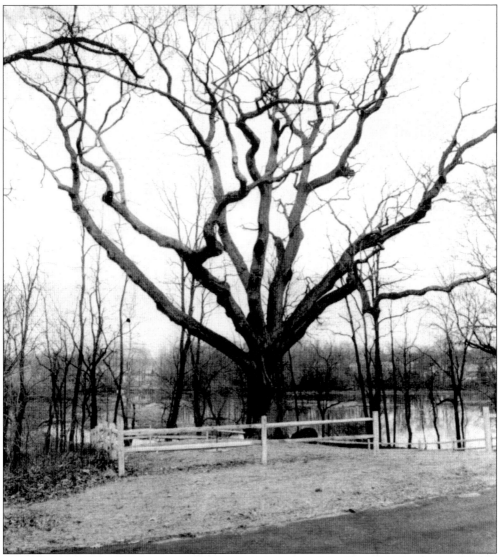

The centuries-old oak known as the Clement Oak is one of the largest in the eastern United States. It was named after the Clement family, whose ancestors can be traced back to the early 1700s in Gloucester County. Samuel Clement, born in 1701, owned 600 acres in Deptford Township. (Courtesy of Herbert I. Clement Jr. and Judy Clement Hensel.)

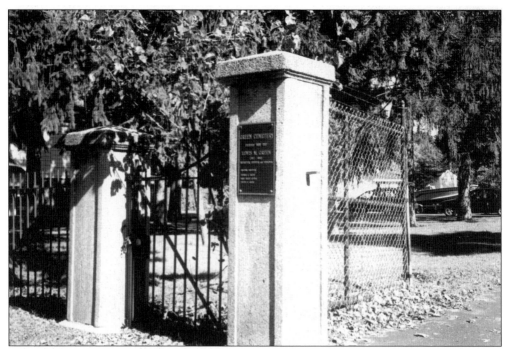

Pictured are the gates to the historic Green Cemetery, now owned by Herbert A. Budd Jr. The entrance to the cemetery is on Tanyard Road right at the Woodbury-Deptford borderline.

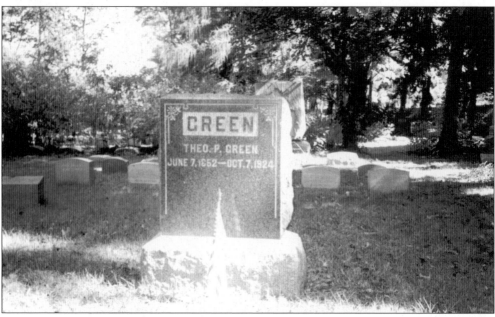

In 1886, Lewis M. Green, a prominent 19th-century Woodbury businessman, purchased a two-acre property on Egg Harbor Road (now Tanyard) near the Deptford-Woodbury line to use as a graveyard. A year later, he bought two other tracts of land that later became Green Cemetery. A monument to Green stands in the cemetery with eight gravestones representing family members. Many Civil War veterans are buried here.

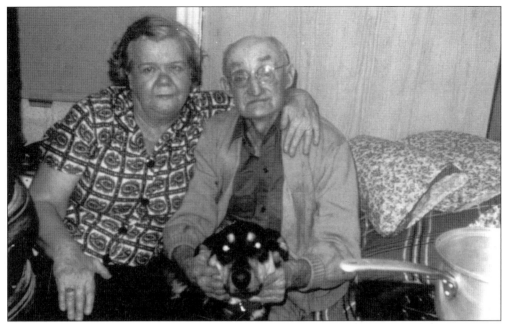

Asa Redrow was the caretaker of Green Cemetery from the early 1930s. Fern, his second wife, moved to his one-room home in the cemetery c. 1942. Asa depended on his memory alone for locations and names of the deceased. He is pictured here with Fern and his dog Katie. (Courtesy of Michael Stronski.)

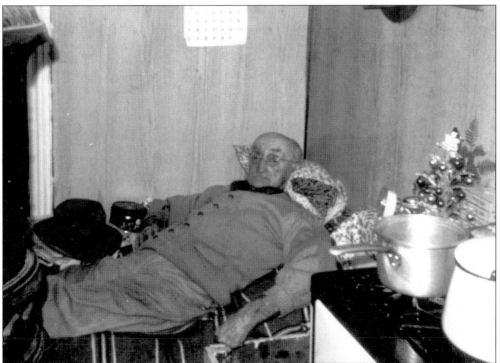

Asa Redrow, the father of nine children, is pictured in the one room he called home at the Green Cemetery. He lived there until his death at the age of 91. (Courtesy of Michael Stronski.)

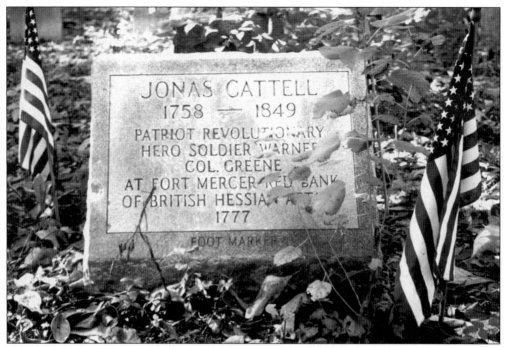

Cattell Cemetery includes the gravesite of Jonas Cattell, a Revolutionary War soldier who died at the age of 91 in 1849. Cattell Road was named after this patriotic hero.

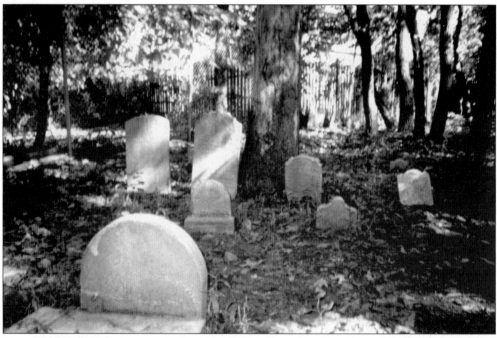

Pictured here are other graves in the Cattell Cemetery, listed as Historical Site No. 28. Jonas Cattell was credited for warning Col. Christopher Greene at Fort Mercer of the British Hessian attack of 1777.

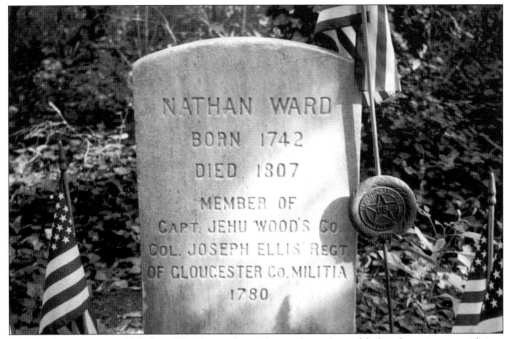

This is the gravesite of Nathan Ward, a military hero who is buried behind a private residence located about a quarter-block from his original homestead. The Nathan Ward house is at the end of Ward Drive, next to the turnpike.

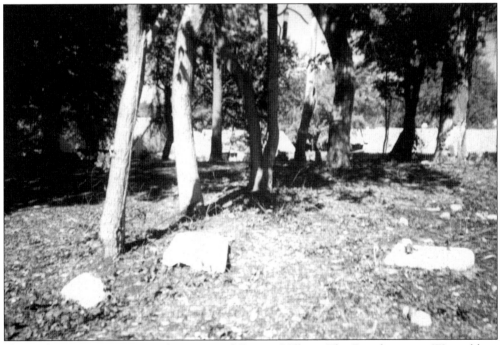

Shown here is a cemetery in the center of Cooper Village. The Revolutionary War soldiers buried here are thought to have served at Fort Mott and Fort Mercer.

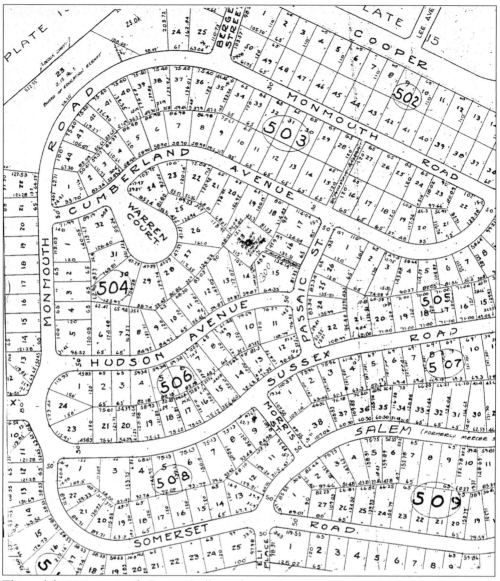

This subdivision map of Cooper Village shows the cemetery surrounded by homes on Cumberland Avenue, Passaic Street, and Hudson Avenue.

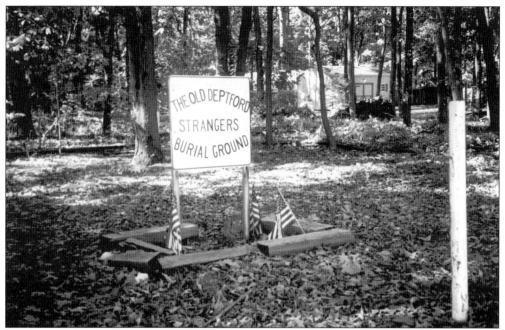

This photograph shows the Old Deptford Strangers Burial Ground, located on Caulfield Avenue off Clements Bridge Road.

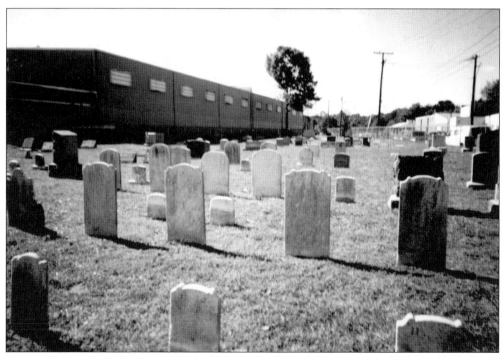

Pictured here is the Almonesson United Methodist Church Cemetery, at 1300 Hurffville Road. This cemetery, founded in 1804, is maintained today by the Almonesson Methodist Church.

SPECIAL NOTICE

In compliance with an act passed by Legislature, all taxes unpaid on October 20th, 1899, will be returned to a Justice of the Peace, and a warrant issued for their collection.

To *Joshua Scott*

Your tax in the Township of Deptford, as found upon the duplicate for the year 1899, is as follows:

Number of acres, _78_

Value of Real Estate, $ *413.00,*

Lots, _____

Value of Personal Property, . . .

Mortgage,

Total value, $

Deduction,

Total taxable, $ *413.00,*

State Poll Tax,

Dog Tax,

State School Tax,30 | *12 90*
County Tax,46 | *19 78*
Roads,10 | *4 30*
Incidental,16 | *6 88*
Township School,40 | *17 20*

Total per cent., . . . $1.42

District Fire,08

Amount of Tax, $ *61.06*

Returnable on the 20th of October next.
Taxes remaining unpaid will be collected with 12 per cent. added.
Taxes remaining unpaid on Real Estate February 1st will be recorded.
The Commissioners of Appeal will meet on Monday, the 11th day of September, at Town Hall, Westville, at 10 a. m. to 3 p. m.
N. B.—I will sit to receive taxes on Tuesday, October 17th, at Town Hall, Westville ; on Wednesday, October 18th, at Cunard's Store, Almonesson ; on Thursday, October 19th, at my home, on Barnsboro and Blackwood road, one mile east of Sewell, 9 a. m. to 4 p. m.

T. B. KIRKBRIDE, Collector.
P. O. Address, SEWELL, N. J.
Money Order Post Office.

Rec'd Payment, *10 – 19 –* 1899.

J B Kirkbride Collector.

BRING THIS WITH YOU.

Collector's Demand for TAXES of Deptford Township for 1909

To *Walter R Scott*
Sewell R 7 D

The valuation of your taxable property and your assessment for taxes in the Township of Deptford for the year 1909 is as follows:—

Number of acres, _____

Value of Real Estate, . $

House and Lots, . . .

Value of Personal Property, . *800*

Total Taxable, . . $ *800*

State Poll Tax, . . . | *1 00*
Dog Tax, . . / . | *50*
State School Tax, . .26 | *2 08*
County Tax, . . .49 | *3 92*
Township Tax, . . .68 | *5 44*

Total per cent. . $1.43

District Fire, . . .07

Amount of Tax, . . $ *12.94*

Rec'd payment *12–16–* 1909

W. C. Allen Collector.

The Gloucester County Board of Taxation will meet in their office at the Court House, in the City of Woodbury, Thursday, November 18th, at 9.30 A. M., and daily thereafter (Saturday excepted), until December 10th, for the purpose of hearing appeals presented in writing. Appeal blanks can be secured by calling on or writing to the County Board of Taxation, at Court House, Woodbury, N. J.

The taxes of the said Township are now due and payable, and that I, the undersigned, the Collector of Taxes of said Township, will attend at the following days and places between the hours of 9 a. m. and 3 p. m. Westville, Monday, December 13th. Almonesson, Wednesday, December 14th. Barnett's store, New Sharon, Thursday, December 16th. Eskin's store, Broad and Magnolia avenue, North Woodbury, Friday, December 17th. At my home, one mile east of Westville, Monday, December 20th, for the purpose of receiving taxes.

Taxpayers who do not pay their taxes on or before the 20th day of December, will be proceeded against as delinquent, as the law defines.

W. C. ALLEN, Collector
P. O. Address—Westville, N. J. Phone connection.

Bring this Notice with you

These are original tax bills for Deptford Township landowners. Joshua Scott owed $61.06 for his 78 acres in 1899, and Walter Scott owed $12.94 for his property in 1909. (Courtesy of Judith Scott.)

This is a picture of the first Clements Bridge, built in 1907 and replaced in 1928. Samuel Clement, family patriarch and surveyor general of New Jersey in the early 1700s, originally owned 600 acres in Deptford around Timber Creek. When he died in 1765, he left one of his farms to his son Joseph and another farm (located nearby) to his other son, Abel. (Courtesy of Herbert I. Clement Jr. and Judith Clement Hensel.)

When the New Jersey Turnpike was built in the early 1950s, it divided the community of Lake Tract. Many residents of Woodbury Lake Road moved from the area as their homes were either destroyed or moved to other streets in Lake Tract. This picture was taken from the Turnpike Bridge on Egg Harbor Road (now Tanyard) facing northbound. The large white house in the background is the Nathan Ward house. (Courtesy of Gladys Pierson.)

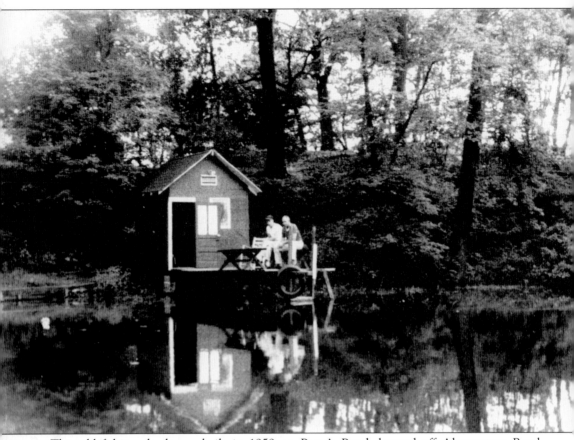

This old fishing shack was built in 1959 on Peter's Pond, located off Almonesson Road. (Courtesy of John Selby.)